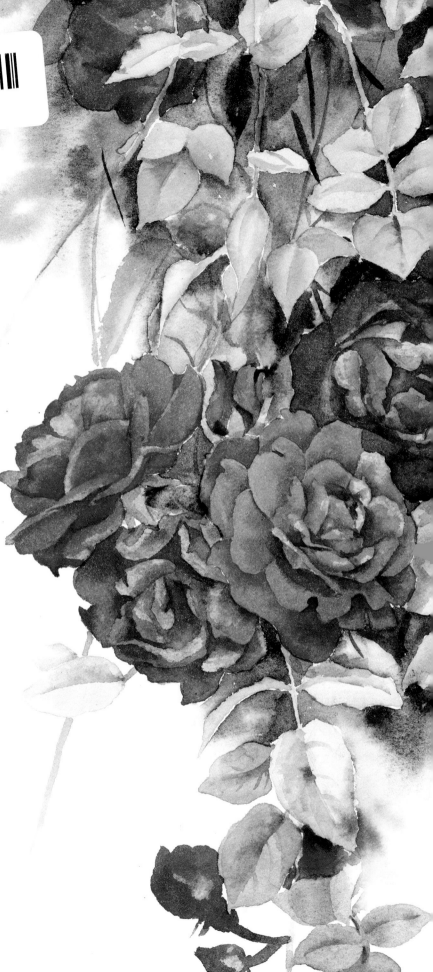

凡花浮影

清新水彩花卉自学教程

冯烨仪 著

化学工业出版社

·北京·

内容简介

本书针对花卉水彩手绘的主题，详细介绍了需要的工具材料、色彩基本知识、水彩绘画技法、花卉形态特征、构图方法和原创创作技法，初学者能从中学习到很多实用的知识。案例部分选择生活中常见的花卉，按从易到难的顺序进行讲解，读者可跟随作者的脚步，发现、记录四时凡花之美。书中每个案例从起形开始，配有详细的图文步骤和视频教程，对于绘画过程中每一步用的颜料色号以及调色方法都进行了详细的描述，读者可轻松自学。本书赠送全书线稿，零基础的读者可拷贝线稿后临摹，增加读者的参与感和成就感。

图书在版编目（CIP）数据

凡花浮影：清新水彩花卉自学教程 / 冯烨仪著. — 北京：化学工业出版社，2023.11

ISBN 978-7-122-44040-2

Ⅰ.①凡… Ⅱ.①冯… Ⅲ.①水彩画-花卉画-绘画技法-教材 Ⅳ.①J215

中国国家版本馆CIP数据核字(2023)第154016号

责任编辑：孙晓梅 　　　　　　　　　装帧设计：景　宸
责任校对：李雨晴

出版发行：化学工业出版社
　　　　　（北京市东城区青年湖南街 13 号　邮政编码 100011）
印　　装：中煤（北京）印务有限公司
787mm×1092mm　1/16　印张 10¼　字数 229 千字　2024 年 2 月北京第 1 版第 1 次印刷

购书咨询：010-64518888 　　　　　　售后服务：010-64518899
网　　址：http://www.cip.com.cn
凡购买本书，如有缺损质量问题，本社销售中心负责调换。

定　价：79.00元

前言

　　本书之所以叫作自学教程，是因为想给喜爱水彩的朋友们一个从入门到进阶的指引。对于初学者，书中详细介绍了各种水彩工具（不同工具特点、用途，不同品牌颜料特点对比等）、色彩基本知识、水彩调色技法、水彩绘画基本技法（平涂、叠色、接色等）、水彩画的构图方法和创作技法，能帮助大家快速进入水彩绘画的世界；书中收录的原创案例很丰富，由简单到复杂，循序渐进，每个案例都附有详细的图文步骤讲解和配套的视频教程，绘画初学者也能轻松上手。对于有一定绘画基础的朋友，书中根据水彩花卉绘制的特点，讲解了花卉相关的植物学知识，结合不同花型花卉的结构线稿，能帮助大家更好地掌握花卉的形态特征。书中还分享了不少我在创作过程中的个人心得，例如如何处理素材等，能帮助大家打开思路，更好地进行渐进式的学习。

　　本书虽是绘画教程，但并不会教条地告诉大家什么是正确的作画方法，而是教大家去感受、观察和练习，这些对于绘画技能的提升才是最重要的。在日常生活中，可爱的花卉无处不在，它们绚烂的姿态无不提醒着我们：一切都是美好的，绘画它们的过程自然也应是美好的。

　　德国诗人莱纳·玛利亚·里尔克曾说："如果你在人我之间没有谐和，你就试行与物接近，它们不会遗弃你。"愿大家能在跟随本书学习的同时，从普通平凡的花卉中，从轻快灵动的水彩世界中，获得美的享受和心灵的谐和，治愈当下。

<div align="right">冯烨仪</div>

目录

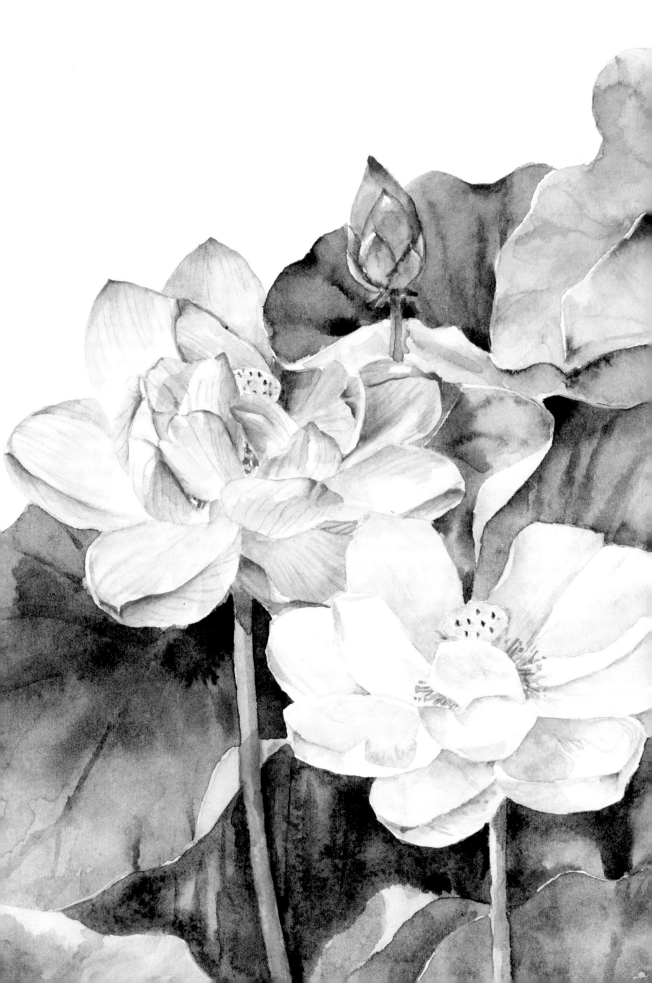

水彩绘画工具

- 工具概览
- 水彩画笔
- 水彩纸
- 水彩颜料
- 辅助工具

工具概览

水彩画的工具繁多，我们只需要挑选好最主要的必要工具，配以偶尔使用的辅助性工具进行作画便足够了。下图是我常用的工具概览，大家可以对水彩画用到的工具有一个初步了解。

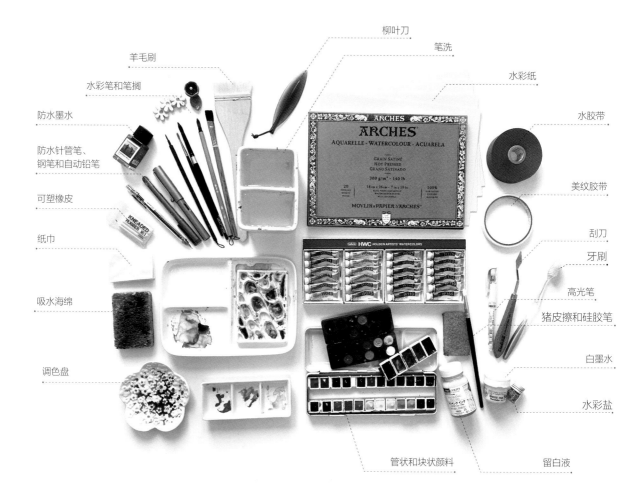

水彩画笔

笔头形状

水彩画笔按笔头形状可以分为圆头笔、勾线笔、平头笔和特殊形状画笔。前三种笔都是较为常用的。特殊形状画笔，如猫舌笔、偏锋笔、扇形笔等，使用场景较少，这里不作详细介绍。

▲ 圆头笔笔尖笔触和笔肚笔触对比

1 圆头笔 有蓄水性较强的笔肚、聚锋的笔尖，适合铺色，笔尖在细节勾画上同样不逊色，笔号选择较多，大号用于大画幅作画，中号用于中画幅，小号则用于小画幅，也可以充当勾线笔。

▲ 勾线笔笔尖笔触和笔肚笔触对比

2 勾线笔 把它单独作为一个形状类别，是因为它有极细长的笔头，笔尖聚锋能力强，适合细节刻画、勾线拉线，笔肚瘦，蓄水有限，不适合大面积铺色。

▲ 平头笔侧锋笔触和平锋笔触对比

3 平头笔 拥有齐平的笔毛和扁平的笔头，除了铺水以外，平锋适合大面积平铺色块及塑造有棱角的边缘，侧锋也可刻画硬朗一点的细节和线条，笔毛偏硬的平头笔还可用于修改擦色。

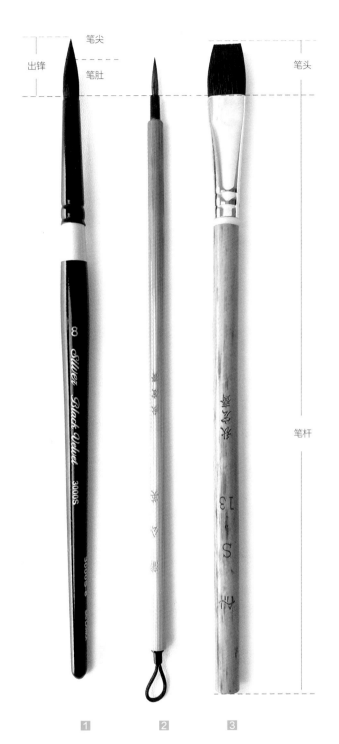

▲ 水彩画笔的结构

笔毛材质

水彩画笔按照笔毛的类型可以分为动物毛笔、尼龙毛笔及混合毛笔，其中动物毛笔又可以分为松鼠毛笔和貂毛笔等。

不同材质的水彩画笔的特点不同，其评价标准包括蓄水性、回弹性、聚锋性等几个方面。

（1）蓄水性

蓄水性指笔头的储水能力，水分通常集中存储于笔肚位置，蓄水能力强则能一次存储大量颜料连续作画，蓄水能力弱则需要多次来回蘸取颜料作画。

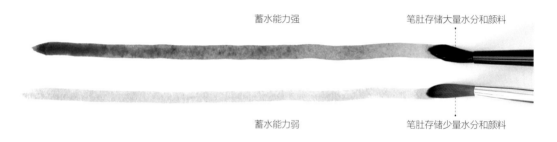

▲ 松鼠毛笔（上）蓄水能力和尼龙毛笔（下）蓄水能力对比

（2）回弹性

回弹性是指作画时笔尖接触纸面后离开画纸时的回弹能力，回弹能力强则毛笔能在对抗纸面压力后迅速恢复原貌，便于继续作画。

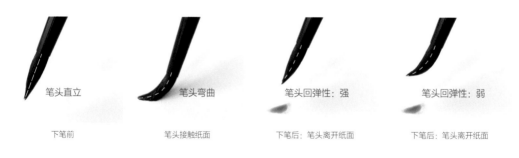

▲ 回弹能力示意

（3）聚锋性

聚锋性是指笔尖在湿润状态下的聚锋能力，聚锋能力越强则笔触越细尖，越能描画细节，聚锋能力弱则笔触较钝。

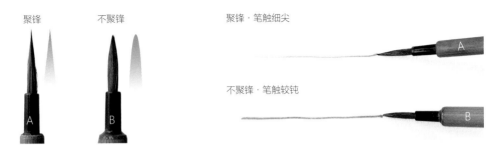

聚锋　　　不聚锋

聚锋·笔触细尖

不聚锋·笔触较钝

▲ 勾线笔新笔与旧笔聚锋性对比

下面从外观颜色、蓄水性、回弹性和聚锋性几个方面来详细了解一下各种笔的特点。

（1）松鼠毛笔

松鼠毛外观为棕黑色，大号的松鼠毛笔笔头像拖把一样，柔软、吸水能力强，适合大面积晕染和铺色。中小号的松鼠毛笔兼具铺色和刻画细节能力。但由于松鼠毛有极强的蓄水能力，在用松鼠毛笔描绘细节的时候，要求绘画者有较强的控水能力。如果水分控制不好，细节刻画会出现水分过多的情况。

（2）貂毛笔

貂毛外观为褐色。貂毛笔弹性比松鼠毛笔大，硬度比松鼠毛笔硬，回弹能力强，笔肚存储水分的同时不会把笔尖的颜料往笔肚带，尤其适合有力度地刻画细节。

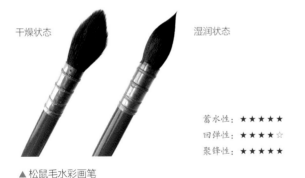

干燥状态　　　　　　　湿润状态

蓄水性：★★★★★
回弹性：★★★★☆
聚锋性：★★★★★

▲ 松鼠毛水彩画笔

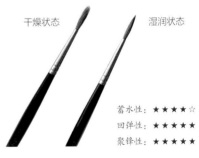

干燥状态　　　　　　　湿润状态

蓄水性：★★★★☆
回弹性：★★★★★
聚锋性：★★★★★

▲ 貂毛水彩画笔

（3）尼龙毛笔

人造尼龙毛有很多颜色，比如白色、褐色等。尼龙毛笔的毛质较硬、回弹力强，但蓄水能力比较差，所以在用尼龙毛笔画画的时候要不断地蘸取调色盘里的颜料，以保证笔肚中有足够的颜料和水分作画。尼龙毛笔的聚锋性不如动物毛笔好，相对容易出现劈叉、变形的情况。但正由于尼龙毛笔的蓄水能力一般，比较适合初学者选用，不会因蓄水过多而控制不住水分。另外在湿画法中，尼龙毛笔也是很好的选择。

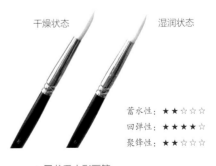

干燥状态　　　　湿润状态

蓄水性：★★☆☆☆
回弹性：★★★★☆
聚锋性：★★☆☆☆

▲ 尼龙毛水彩画笔

（4）混合毛笔

混合毛笔是动物毛和尼龙毛混合制成的笔。某种程度上来说，它是改良版的尼龙毛笔，在保持了尼龙毛笔高回弹性的同时，增加了动物毛才有的蓄水能力。市面上很多混合毛笔的质量都相当不错，而且价格亲民，是性价比较高的选择。

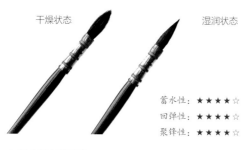

干燥状态　湿润状态

蓄水性：★ ★ ★ ★ ☆
回弹性：★ ★ ★ ★ ☆
聚锋性：★ ★ ★ ★ ☆

▲ 混合毛水彩画笔

（5）书法毛笔

这里顺便介绍一下书法毛笔。书法毛笔制作之初是为了书法使用，后来也在水彩绘画中使用，挑选时应注意避开纯羊毛或兔毛的软毛笔，选择回弹能力好的狼毫笔。狼毫笔以狼毫为内芯，外披其他动物毛，兼备回弹能力和蓄水能力，聚锋性也不错。

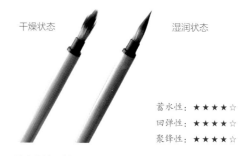

干燥状态　湿润状态

蓄水性：★ ★ ★ ★ ☆
回弹性：★ ★ ★ ★ ☆
聚锋性：★ ★ ★ ★ ☆

▲ 狼毫书法毛笔

我常用的画笔

根据画笔的材质与制作工艺的不同，其价位也各不相同，但并非价格越高的笔就越好，也并非人工合成毛笔就不如天然动物毛笔优秀。一切都要在日常实践中，结合自己的实际情况作定夺。这里介绍一下我日常作画时常用的两套画笔（图A，图B），以供大家参考。

这套笔足够平日使用，中间三支铺色笔②③④取一即可，我平日使用频率较高的搭配是②⑤，一幅8开以下的小画，这两支笔足够使用。但狼毫笔消耗比较快，随着使用时间变长，笔锋会慢慢变钝，需经常换新笔。

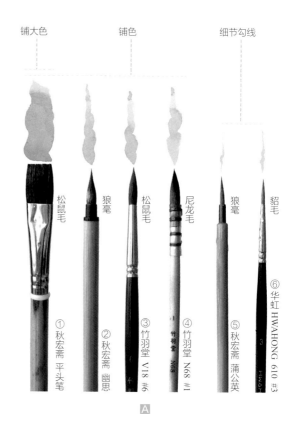

铺大色　　铺色　　细节勾线

① 秋宏斋 平头笔　松鼠毛
② 秋宏斋 幽思　狼毫
③ 竹羽堂 V18 #6　松鼠毛
④ 竹羽堂 N68 #1　尼龙毛
⑤ 秋宏斋 蒲公英　狼毫
⑥ 华虹 HWAHONG 610 #3　貂毛

Ⓐ

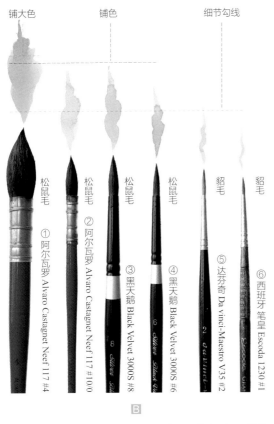

铺大色　　　　铺色　　　　　细节勾线

松鼠毛　① 阿尔瓦罗 Alvaro Castagnet Neef 117 #4

松鼠毛　② 阿尔瓦罗 Alvaro Castagnet Neef 117 #10/0

松鼠毛　③ 黑天鹅 Black Velvet 3000S #8

松鼠毛　④ 黑天鹅 Black Velvet 3000S #6

貂毛　⑤ 达芬奇 Da vinci-Maestro V35 #2

貂毛　⑥ 西班牙笔皇 Escoda 1230 #1

B

这套笔的特点是一支笔能支撑多种画幅，且较为耐用，保养得当可以持续使用数年，价位在中高水平。在描绘小画幅的花卉题材时，我最常用的搭配是④⑥。

特殊功能画笔

1 **华虹 HWAHONG 羊毛刷** 羊毛刷用于大面积铺水，用羊毛刷刷水可以使画纸快速达到均匀浸润的状态，便于后期湿画。

2 **竹羽堂平头修改笔** 用于修改色稿，把颜色洗擦掉，硬尼龙毛能有效摩擦纸面，把颜色擦走，但不可多次反复使用，否则会损伤纸面。

1　　2

▲ 特殊功能画笔

画笔的使用与保养

（1）开笔

　　新购入的水彩画笔为了保护笔毛，使其与空气隔绝，是处于封胶状态的，所以需要做开笔的处理。把画笔放进水中使其湿润，用手指轻轻揉搓，把胶膜洗掉，再用清水洗一次即可。

（2）放置与收纳

　　使用过后的画笔用清水洗干净，用纸巾轻轻吸干余水，倒插在笔筒中晾干。不常用的画笔可待画笔完全干透后放在画笔收纳盒或收纳袋中。

▲ 收纳袋、笔搁、笔筒

（3）清洁保养

　　画笔日常使用时会在笔毛内残留颜料等，所以需要用水彩画笔专用的洗笔皂定期清洁，以延长画笔的寿命。一周到两周清洁一次即可。另外，如果笔尖的毛弯了，可以使用温水浸泡，然后用手把笔毛捋直。

水彩纸

市面上售卖的水彩纸有四面封胶水彩本、水彩散纸、小型便携水彩本以

▲ 用柳叶刀取下纸张

▲ 四面封胶水彩本

▲ 美纹胶带　▲ 水胶带

▲ 小型便携水彩本　　▲ 散纸

及各种样式和造型的水彩本，如圆形、方形等。四面封胶水彩本上作画后可直接取下纸张，是易于保存和使用的一种水彩本。一般用柳叶刀取下纸张，也可以用各种硬卡片代替，但注意不要使用刀片。散纸可以直接使用，适用于固定场所的创作，绘画前需要裱纸。另外，散纸需要用密封袋存放，隔绝空气，避免受潮和暴晒，以防脱胶。

小贴士

▲ 脱胶点

什么是脱胶？

水彩纸的表面有一层胶，可以理解为使颜色和纸黏合在一起的媒介，这层胶受潮受光后容易脱落，这种现象称为脱胶。脱胶的水彩纸不易上色，甚至上不了色。因而新购入的水彩纸要密封保存，尽快使用。

水彩纸的材质和纹理

水彩纸按材质可分为木浆纸、棉浆纸和棉木混合浆纸，本书中的画作主要使用全棉浆制成的水彩纸。

水彩纸按纹理可以分为细纹水彩纸、中粗纹水彩纸和粗纹水彩纸，纹理不同，画出来的效果也有所不同。

▲ 细纹水彩纸

▲ 中粗纹水彩纸

▲ 粗纹水彩纸

细纹水彩纸的特点是纹理细致、纸张密度高、表面光滑，适合表现细致的画面，如写实风格题材。在绘画时水分吸收快、画纸干燥得快、容易形成水痕，因而要求绘画者有较高的控水能力。

中粗纹水彩纸的特点是纹理粗糙、纸张密度适中、表面有均匀的凹凸纹理，适合大多数的绘画题材。在绘画时水分吸收慢、画纸干燥慢，能给绘画者较充足的时间做画面晕染堆叠变化等。

粗纹水彩纸的纹理比中粗纹水彩纸更为粗糙，纸张表面的凹凸感更强，比较适合粗犷自由的作画风格，容易表现"飞白效果"（画笔快速描绘，通过纸面凹凸不平的纹理创造不同程度的留白块面）。

水彩纸的厚度

水彩纸厚度的计量单位是 g(克)，按克重分为 180g、200g、300g、600g 等。克数越大，纸张越厚。薄的水彩纸吸收水分后，容易起皱，反复叠色或揉搓纸面容易产生起毛，甚至渗烂的情况。克重越大的水彩纸，承受能力越好。因为本书的画作中会进行数次叠色和晕染，所以选用的是 300g 的水彩纸。而在进行大幅画面创作时，需要选择更高克数的纸。

水彩纸的大小

水彩纸纸张大小的计量单位是 K（开），按开数可分为 64K、32K、16K、8K、4K、2K、全开等。开数越大，纸张越小。可根据作画场景题材选择合适大小的画纸，也可购买大张的画纸，用裁纸器裁切成自己需要的大小作画。

水彩纸的白度

水彩纸都是白色的，但是白度却不同。偏黄的纸，色泽温和、不刺眼；越白的纸，色彩还原度越好，在扫描作品成电子版本时，色差越小。绘制清新的花卉主题水彩画时，宜选用白度高一些的画纸。另外市面上还有各种做旧泛黄的或带有毛边的水彩纸供选择。

水彩颜料

下面我们来认识一下水彩颜料。了解了各种颜料的特性，即使是普通的颜料，也能发挥它最大的作用。

水彩颜料的基本知识

（1）原料

水彩颜料主要由载色剂、色料以及其他成分调和而成，载色剂一般是阿拉伯树胶，其他成分还有蜂蜜、甘油、防腐剂、牛胆汁等，其中牛胆汁可增强颜料的扩散性。色料有取自大自然（如矿石、贝壳、植物、动物等）的，也有人工合成的。

（2）色料分级

水彩颜料可根据原料的珍贵程度进行分级，如 A、B、C、D、E、F，字母越靠后，级别越高，原料获取越难，售价也越贵。通常基础色里大部分是低级别的颜料，但不同品牌会有所不同。

（3）灌装方式

水彩颜料的生产厂家为了匹配不同颜料的储存和使用场景，会生产不同灌装方式的颜料，大致可分为管彩和块彩两种。

1 管彩。管彩是用软管灌装的水彩颜料，特点是流动性强，每次使用时挤出少量颜料在调色盘里调色使用，适合固定场所使用。管彩的密封管设计给予了颜料良好的保存条件。另外管彩也可以挤到分装盒子中固化后使用。

2 块彩。块彩是固体的水彩颜料块，一般配套颜料盒一起售卖，市场上也有单个的补充色块售卖。使用时利用笔尖的水分蘸取颜料块进行取色。特点是小巧、省空间，颜料不会流动，便于携带，是出外写生的好伴侣。但由于块彩的密封性不如管彩，所以对颜料的稳定性有一定影响，长期放置不使用或置于潮湿环境中可能出现发霉变质的情况。

水彩颜料的常见品牌

市面上的水彩颜料多种多样，不同品牌生产的水彩颜料有不同的特点。下面我们来了解一下常见的水彩颜料品牌。

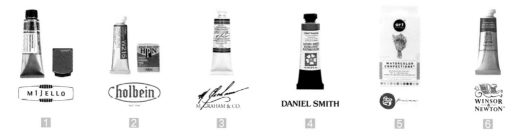

1 美捷乐（Mijello） 这是一个来自韩国的品牌，有白级（White Class）和金级（Gold Class），相当于学院级和艺术家级。特点是颜色鲜亮、透明度高、扩散性一般，比较适合植物绘画。

2 荷尔拜因（Holbein） 这是一个来自日本的品牌，颜色风格清新鲜亮，有多种规格和套装可供选择。颜料的扩散性不强，容易控制，同样适合植物绘画，也是绘制清新系插画的不错选择。

3 格雷姆（M.Graham） 这是一个来自美国的品牌，其颜料特点是质地丝滑柔软，颜色鲜亮浓郁。它的扩散性很强，因而很适合混色晕染，也正是由于它的强扩散性，小范围混色需要画者有很强的控水能力，避免颜色堆叠和冲撞过于强烈。

4 丹尼尔·史密斯（Daniel Smith） 这个品牌的颜料以沉淀色、矿石色以及宝石珠光色为特色，由矿物、贝壳等研磨制成，具颗粒感和重量感。珠光色在光下会形成闪耀的感觉。这款颜料在表现肌理和特殊效果方面都给予了画者很大的发挥空间和惊喜。

5 佩玛（Prima） 这是一个专门做系列水彩的品牌，有大地色系、海洋色系、热带色系等，十分有趣。颜色靓丽鲜明，搭配好的色系适合绘制不同类型的题材，配色让人眼前一亮，颜料各方面表现都不错。每个系列小巧精致，是进行水彩创意或日常携带出门写生的不错选择。

6 温莎牛顿（Winsor Newton） 这个品牌的水彩颜料性价比很高，颜色各方面表现出色且价格亲民，适合各类题材的画作。该品牌中学院级的歌文系列表现不俗，对于新手来说，是一款容易上手、不会出错的颜料。

我常用的水彩颜料

我常用的水彩颜料是美捷乐金装 24 色套装和荷尔拜因植物色系 24 色套装，这两款颜料会在后面的案例中使用。从下面的色卡可以看出，两者的颜色都很清爽透明，有很多适合花卉和绿植的颜色。细心对比可以看到，有些颜色虽然名字相同，但是不同品牌呈现出来的色相是有差别的，例如霍克绿、天蓝等。美捷乐的颜色更加浓郁鲜艳，荷尔拜因的颜色更加清爽淡雅。对于初学者来说，荷尔拜因更容易适应一些。

（1）制作色卡

我们拿到新颜料以后，首先可以进行的是色卡制作。如下页两张色卡图所示，我习惯用单色渐变的方法按官方顺序制作每个颜色的色卡，以便看到同一颜色在不同水分下的颜色变化。色卡制作方法如下。

1 在水彩纸上画好格子，标注好颜色编码和名称，在格子里铺一层清水。

2 笔尖沾一点清水后蘸取颜料。

3 从上方开始铺最浓的颜色，慢慢地铺到中间部位。

4 把笔头洗干净并吸干水分后，将颜色晕开至最下方，最下方颜色最浅。

制作色卡的过程也是试色的过程，色卡做完后，我们会发现，颜料盒中所见也许并非所得：永固紫在颜料盒中的颜色和实际上色差别很大，颜料干和湿的状态之间，颜色也存在差异。

色卡上的颜色呈明显的、深浅不一的紫色。

颜料干固后的颜色呈接近黑色的深紫色。

颜料在调色盘中的颜色有深有浅，呈多种明度的紫色，较鲜亮。

颜料在水彩纸上没干时的颜色呈较鲜艳的紫色，纸张凹凸感使颜色有深浅变化。

颜料在水彩纸上干掉后的颜色呈变灰、变浅的紫色，颜色均匀且有水痕边界。

▲ 荷尔拜因 W115 永固紫在不同载体上的颜色差别

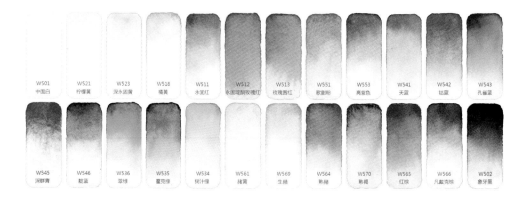

▲ 美捷乐金装 24 色色卡图

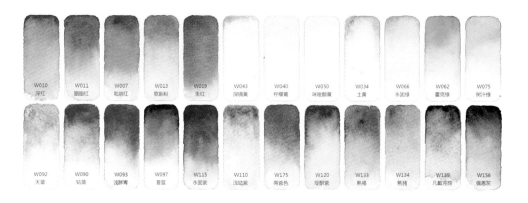

▲ 荷尔拜因植物色系 24 色色卡图

（2）试色

在实际作画的调色步骤中，除了参照色卡调色，还需要进行试色，可以在旧水彩纸上尝试调配好的颜色，进行对比，直到颜色满意了再下笔上色。

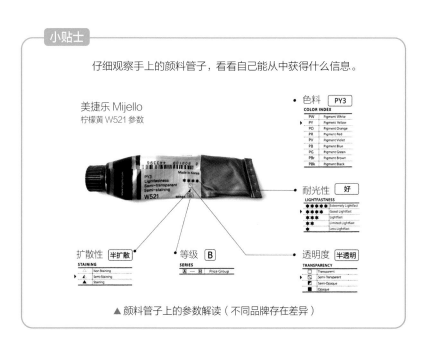

▲ 颜料管子上的参数解读（不同品牌存在差异）

水彩颜料的特性

（1）透明度

水彩颜料按透明度不同分为全透明水彩、半透明水彩和不透明水彩。透明度可以理解为该颜料的遮盖力，遮盖力越高，透明度越低。

半透明　　透明　　不透明

▲ 颜料透明度对比

（2）扩散性

扩散性指颜料在画面中的扩散程度，扩散性强的颜料遇水能迅速蔓延，适合表现背景渲染变化和水痕冲撞的效果；扩散性弱的颜料遇水则小范围蔓延，更容易控制渲染范围，比较适合小区域刻画，表现细节，或用于表现写实风格。

> **小贴士**
>
> 往扩散性弱的颜料里添加牛胆汁可增强扩散性。
>
>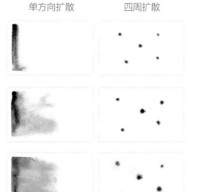
>
> 没有添加牛胆汁　　　添加牛胆汁后
>
> ▲ 添加牛胆汁前后扩散性对比

扩散性 ▲▲▲▲▲　　　　颜料：格雷姆

扩散性 ▲▲▲　　　　颜料：美捷乐

扩散性 ▲　　　　颜料：荷尔拜因

▲ 不同品牌颜料的扩散性对比

由于颜料在画纸上是以水为载体的，所以水量的多寡也会影响颜料的扩散能力。水量越大，阻力越小，扩散能力越强；水量越小，阻力越大，扩散能力越弱。

测试颜料： 格雷姆 M · Graham #189 绿松石色

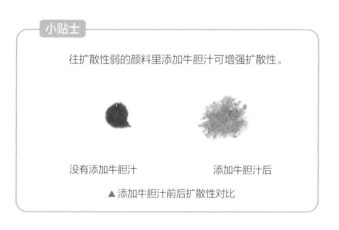

单方向扩散　　　四周扩散

水量▲
纸面刚能湿润的状态
扩散性 ▲

水量▲▲▲
纸面浸润的状态，但水面无凸起
扩散性 ▲▲▲

水量▲▲▲▲▲
纸面完全浸润的状态，且水面凸起，有一定厚度
扩散性 ▲▲▲▲▲

▲ 水量和颜料扩散能力的关系

除了水量之外，时间也是一个重要的因素。扩散范围会随着时间的增加而加大，颜色会逐渐变淡并和邻色交融。

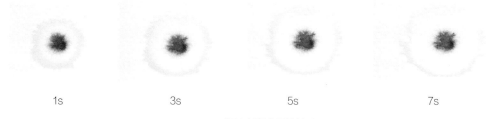

| 1s | 3s | 5s | 7s |

▲ 时间和扩散范围的关系

（3）耐光性

颜料的耐光性是指颜料暴露在空气中对光的耐受性。耐光性强的颜料随时间的推移不易产生颜色的变化，更利于画作的保存；耐光性弱的颜料则容易变色发灰。个别颜色由于原料的关系，耐光性比较差。

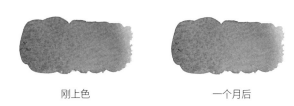

刚上色　　　　　　　　一个月后

▲ 美捷乐 W553 亮紫色，暴露在阳光和空气中一个月后颜色变淡

（4）溶解性

溶解性指颜料遇水即溶的能力强弱，可以理解为颜料取色的容易程度。选择溶解性强的颜料能让作画过程更加便捷和顺畅，像美捷乐和格雷姆都是溶解性不错的颜料。另外某些颜色的颜料特性使其难以取色，如含钴的颜料。

轻轻取色后得到的颜色

用力取色后得到的颜色

▲ 溶解性差的颜料取色示例

辅助工具

通过前面的讲解，相信大家已经对水彩工具有了大致的了解，下面我们还需要了解一些辅助型的绘画工具，虽然它们不会经常用到，但也是必要的绘画工具。

线稿用笔

开始作画时，我们需要对画面起形。线稿用笔可以选用铅笔、针管笔、钢笔、蘸水笔等。

▲ 三菱自动铅笔和荷尔拜因可塑橡皮

▲ Copic 彩色针管笔

▲ 凌美钢笔和采墨棕色防水墨水

▲ 防水墨水和巨匠蘸水笔 EF 笔尖

（1）铅笔

建议选用自动铅笔，因为容易携带，也省去削笔的工具。可搭配可塑橡皮使用。可塑橡皮的优点是使用时不伤纸面，不留纸屑。

（2）针管笔

使用防水型的针管笔，一般选择 0.1mm 的笔头。针管笔颜色很多，其中棕色是较为百搭的颜色。

（3）钢笔

使用普通签字钢笔，钢笔笔头有弹性，能控制线条粗细，线条变化比针管笔丰富。需要搭配防水型的墨水，墨水也有很多颜色可选，我一般只用棕色和黑色。

（4）蘸水笔

蘸水笔相当于没有墨囊的钢笔，需要蘸取墨水使用，在水彩画中，也需要搭配防水型的墨水使用，适合在固定的室内场所作画时使用。另外蘸水笔笔杆可搭配多种笔头使用，因而能画出富于变化的线条。

白墨水和留白液

（1）白墨水

白墨水是具有覆盖力的白色颜料，用于画面覆盖、提亮。另外也有笔状的同类型产品——高光笔，用于细节点涂，优点是方便携带。

1 涂出花朵形状。

2 花朵颜色干透后，蘸取白墨水描画出花蕊形状。

3 白墨水干透后，添加花蕊颜色。

▲ 使用白墨水画花蕊

▲ 鲁本斯白墨水和三菱高光笔

▲ 荷尔拜因留白液、硅胶笔和猪皮擦

（2）留白液

留白液是一种胶状液体，干后成膜，能有效隔绝颜料和水分，阻止颜色渗透，用于画面预留白处理。涂抹留白液的工具通常是硅胶笔，也可以使用旧的毛笔或自来水笔等工具。在涂抹细小部位时，也可以使用牙签、蘸水笔等工具。

1 用旧勾线笔涂上留白液，描画出花蕊的形状。

2 留白液干透后，涂出花朵形状。

3 花朵颜色干透后，用猪皮擦擦掉留白液。

4 在留白的花蕊部位涂上花蕊的颜色。

▲ 使用留白液画花蕊

外出写生的工具

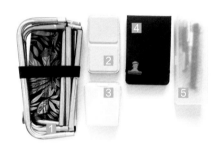

1 小马扎 2 水彩颜料铁盒 3 便携洗笔筒 4 小型水彩本 5 笔盒（内含自动铅笔、防水针管笔、便携水彩笔、高光笔、自来水笔）

▲ 外出写生常用工具

裱纸工具

水彩纸吸收水分后，纤维会膨胀拉伸，导致在作画过程中纸面凹凸不平，影响绘画效果和体验。裱纸能很好地解决这个问题，但非必要的选择，在户外写生或绘制小画幅作品时，裱纸的步骤可以省略。

裱纸步骤如下。

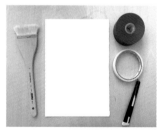

1 **准备工具。** 裱纸需要用到美纹胶带、水胶带、美工刀、画板、羊毛刷和水彩纸。

2 **刷水。** 把水彩纸放置在干净无污渍的画板上，用羊毛刷往纸上刷水，正反面都要刷到，反复刷 2~3 次，每次停留 10s 左右，让纸纤维充分吸收水分从而延展开来。纸张较大较厚时，也可以把水彩纸放进盛满冷水的容器里浸透后取出。

3 **固定。** 用水胶带把刷完水的水彩纸四边固定在画板上，固定时绷紧水彩纸，先固定长边，再固定短边。

4 **晾干。** 晾干后的纸面呈现平整而绷紧的状态，纸和画板之间无气泡。最后，用美纹胶为画面留白边，如果不需要留边，这个步骤可省略。

作品的收纳工具

最后，画好的作品需要好好保存。如果是水彩本，只需放在遮光干燥处收纳好即可。如果是散纸，可以把相同尺寸的作品放在水彩画收纳册里，收纳成册。也可以用裱画框把作品裱起来，镶进画框或挂在墙上。

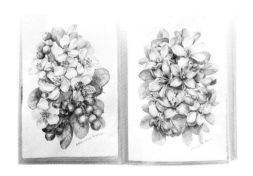

▲ 水彩画收纳册

▲ 裱画

小贴士

如何保持画面干净

（1）线稿阶段

①在用铅笔起稿时，从画纸的左侧开始作画（以右手作画为例）。

②用可塑橡皮吸附铅笔屑，或用桌面吸尘器把铅笔屑吸干净。

③使用拷贝台。把预先画好的线稿通过拷贝台拷贝到水彩纸上。

（2）上色阶段

①保证足够的创作空间，避免拥挤。

②遵循有序的上色动线（以右手作画为例）。

③使用绘画手套。

④使用吹风机，确保上一层色稿完全干透后再进行下一步操作。

⑤使用硫酸纸局部覆盖画面，避免蹭脏。

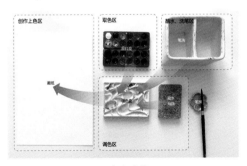

▲ 上色动线

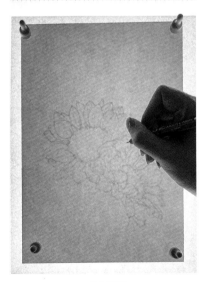

▲ 绘制线稿

▲ 硫酸纸的使用方法

|第 2 章|

色彩基本知识

- 从色环开始了解色彩
- 从色彩的三属性学习调色
- 学会观察色彩
- 从大自然中学习色彩的搭配

从色环开始了解色彩

人眼受可见光不同波长的刺激产生了红、橙、黄、绿、青、蓝、紫等颜色的感觉，每种颜色对应一个波长值，这种像彩虹般的颜色称为光谱色。把光谱色头尾相接卷成一个环形便形成色环。把色环分割成12个颜色就形成12色环。色环是学习色彩的重要辅助工具。

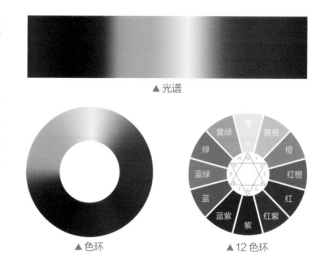

▲光谱

▲色环　　　　▲12色环

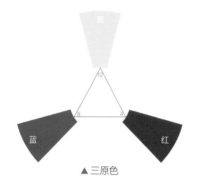

▲三原色

三原色

三原色即黄、红、蓝，我们无法用其他颜色调出这三个颜色，因此称之为"原色"。理论上来说，三原色能调出任何一种颜色。三原色等比例混合理论上会得出无彩度色，实际操作中更多的是得到一个带颜色偏向的灰黑色。

二次色

二次色即橙、紫、绿，之所以叫作二次色，是因为理论上它们是三原色的产物：黄加红得到橙色，红加蓝得到紫色，蓝加黄得到绿色。虽然理论上可行，但实际调色时，我们一般选择现成的二次色，因为颜色会更加纯正。

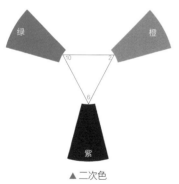

▲二次色

▲黄＋红＝橙

▲红＋蓝＝紫

▲蓝＋黄＝绿

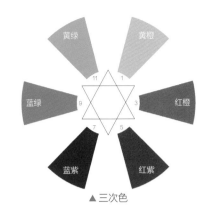

▲ 三次色

三次色

三次色即黄橙、红橙、红紫、蓝紫、蓝绿、黄绿。三次色是二次色的产物，例如黄橙色由黄色和橙色调配而成，其他颜色以此类推。三次色也是使用频率较高的调色基础色，一般在 24 色颜料中能找到它们。

▲ 黄＋橙＝黄橙　▲ 红＋橙＝红橙　▲ 红＋紫＝红紫　▲ 蓝＋紫＝蓝紫　▲ 蓝＋绿＝蓝绿　▲ 黄＋绿＝黄绿

邻近色

邻近色是指色环中相邻近的颜色，例如橙色的邻近色是黄橙色和红橙色。富于变化的邻近色搭配起来既和谐，又可以使颜色活跃、不单调。

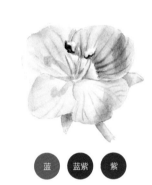

▲ 蓝色和紫色邻近色配色的婆婆纳

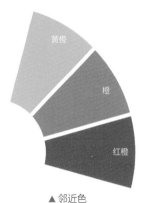

▲ 邻近色

类似色

在色环中，从邻近色向两侧再次拓展，拓展到 3~5 个颜色族群，就得到类似色（相似色）。类似色不能超过 5 个，因为色环中相对的两个颜色是互补关系，不能形成类似色。例如图中这组类似色不能再拓展到橙色旁边的红橙色，因为红橙色里面的红色是绿色的补色，会打破这组类似色的和谐感。

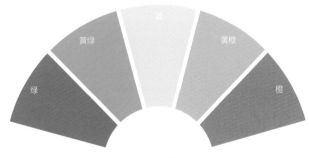

▲ 类似色

补色

补色是指色环中相对的两个颜色，它们有互补性，能补足对方的不足以达到均衡的感觉。在色彩中，"均衡"可以理解为三原色同时存在。以图中黄紫互为补色为例，黄色是三原色之一，而紫色是由三原色中的红色和蓝色混合得到的二次色，所以这对补色包含了三原色，是均衡的。我们从色环中任何一对补色中，都能找到三原色的存在。

补色等比例混合会得到一个无彩度色。这种操作也叫消色，意思是这两个颜色互相抵消了。

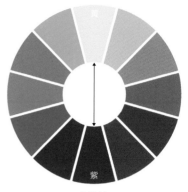

▲ 补色

▲ 红＋绿消色　▲ 黄＋紫消色　▲ 蓝＋橙消色　▲ 黄橙＋蓝紫消色　▲ 红橙＋蓝绿消色　▲ 红紫＋黄绿消色

▲ 三联体示例

▲ 四联体示例

均衡的色彩

上面说到补色的均衡性，下面我们来延伸一下，了解色彩的均衡性。

色彩的均衡性可以理解为我们的大脑对色彩的一种生理上的舒适协调的要求。在生活中我们能发现，人类追求自然和谐的生活、平衡的结构、美的视觉感受等是与生俱来的本能，是具有生物性的。同样的，我们喜欢均衡协调、舒适安定的色彩，这些色彩能让我们产生美妙的感觉。我们排斥刺激、极端、不协调的色彩。

色环上的补色、三联体、四联体当中都含有三原色，都可以使色彩均衡，也都可以产生消色，我们在调色时常会运用到消色的调色原理。

从色彩的三属性学习调色

学习调色前，先要了解调色中需要运用的颜色的三大属性：**色相、饱和度和明度**。调色始终围绕这三个属性进行着：感性地观察，理性地调色，再感性地下笔。

色相

调色的第一步是识别颜色。色相用于描述颜色的相貌，或者说是颜色的名字，如12色环中的黄色、蓝色、红色……这些名字定义了颜色的色相。还有其他的一些色相，例如很像孔雀羽毛颜色的"孔雀绿"，和薰衣草的颜色很接近的柔和的"薰衣草紫"。这些具象的色相（色名）能让我们快速识别颜色，同时赋予颜色更多的意义。

▲孔雀绿

▲薰衣草紫

识别色相

24色的颜料有24种色相，但每次画画通常只需要用到10种左右，一些三次色之外的特殊色是很少用到的，因此识别三原色、二次色、三次色足以支撑我们的画作。在调色时，可以把色环图片放在案边，取色的时候自觉地问自己，需要调的这个颜色来自于色环的哪个位置？它的旁边是什么色？它的对面是什么色？这样的重复练习对调色有很大的帮助。

饱和度

饱和度指颜色的鲜艳程度，也叫彩度。饱和度越高的颜色越鲜艳，饱和度越低的颜色越浑浊。颜料锡管里刚取出的颜色的饱和度是最高的，之后每一次调色都会降低其饱和度，我们无法调出比原色更鲜艳的颜色。

（1）识别饱和度

日常生活中我们可以通过对比观察，对颜色进行饱和度分级。例如下图的4个绿色，由左到右饱

和度逐渐降低。日常观察事物的时候，可以形容一下它的饱和度，它和旁边的物体，谁更加鲜艳？不仅作画时，任何时候都可以进行这样的练习。

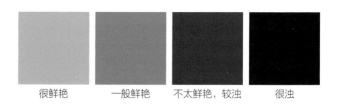

| 很鲜艳 | 一般鲜艳 | 不太鲜艳，较浊 | 很浊 |

▲ 同色相、不同饱和度对比

（2）调色时如何降低饱和度

①添加补色。添加补色可以降低饱和度。任何颜色，只要添加一点补色，就可以得到相对不鲜艳的颜色，添加的补色越多，颜色越浊，当二者比例相同时，会消除彩色，得到一个无彩度的颜色。添加补色时，色相会以分量多的颜色为主导，调色是动态平衡的关系，就像跷跷板的两端，哪一边的颜色分量重了，色相就偏向哪一边，十分有趣。

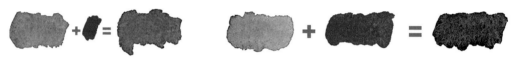

▲ 在绿色中添加少量补色，得到低饱和度绿色　　　　▲ 在绿色中添加等量补色，得到无彩色

②添加低饱和度色。往目标颜色中添加其他低饱和度的颜色，必定会使其饱和度降低，但由于添加的颜色存在色相偏差，这种方法会改变原色的颜色偏向，但也算是一种调色的捷径。例如，如果想把绿色调成偏棕黄调的灰绿色，我们可以往绿色里直接添加灰棕色。也许你会说，这太麻烦了，哪里有灰棕色呢？别忘记我们的调色盘里常常混有各种各样的"灰"，找到那个偏棕黄色的灰，这时候这些看似没用的"脏色"就派上用场了。

③添加黑色。大家可能想说，降低饱和度为何不直接添加黑色。添加黑色当然是可以的，一些颜色添加黑色会得到很漂亮的颜色，例如黄色添加黑色会得到很柔和的橄榄绿。但是相较于添加补色的方法，黑色在降低饱和度的同时，把明度也一并降下去了，会使颜色变得较为稳重但沉闷，由于色料的关系，有时有一种不透气的感觉。添加补色的优势在于降低颜色饱和度的同时保持颜色的活泼性。而关于黑色，大家可以多尝试它和其他颜色混合，看看会得到什么意想不到的颜色。

（3）调色时如何提高饱和度

我们无法调出比颜料锡管中刚取出的颜色饱和度更高的颜色，但是可以通过改变环境色，在对比中凸显颜色的饱和度。例如把饱和度低的颜色放在旁边，会显得原色饱和度更高。如右图所示，两个一样色值的黄色，左边的黄色因放置在更暗的紫色中，显得更加明亮、鲜艳。

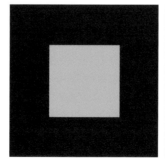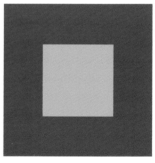

▲ 环境色对饱和度的影响示例

明度

明度是指颜色的深浅程度，颜色越浅明度越高，颜色越深明度越低。我们可以利用灰阶图来辅助理解颜色的明度。下图是没有彩色的灰阶图，一共16格，左端是纯白色，右端是纯黑色，左侧明度最高，右侧明度最低。

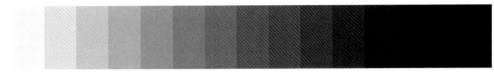

▲ 16 灰阶图

那么添加了彩色以后，我们要怎样识别颜色的明度呢？下图中有11个明度级别，中间数字6是基准色，我们能看到越往左边，蓝色越浅，最左边是白色，明度最高；越往右边，蓝色越暗，最右边是黑色，明度最低。

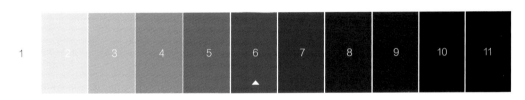

▲ 蓝色（群青）的明度级别图

（1）调色时如何提高颜色的明度

以上面蓝色的明度级别图为例，在水彩画中，提高颜色明度的主要方法是添加水分，让颜色变浅。我们以图中位于中间（数字6）的蓝色为基准色，往左逐渐添加水，添加的水越多，则蓝色越浅，明度越高。

或许你会说，使颜色明度变高，为什么不加白色颜料？确实可以通过添加白色让颜色明度变高，尤其在一些丙烯、油画和水粉画中，添加白颜料是提高明度的方法。但在水彩画中，白色颜料会降低水彩颜料的透明度，让它变得不透明，增加颜色的厚重感和粉感。而这最终还是取决于你需要的画面感受，若追求透明感，加水即可。

（2）调色时如何降低颜色的明度

以上面蓝色的明度级别图为例，中间的蓝色往右依次添加黑色颜料，添加的黑色颜料越多，则蓝色越深，明度越低。

（3）颜色自身明度影响明度的调节

基准色本身的明度也影响着明度的调节。我们把12色环调节成无彩色版本，可以看到，每个颜

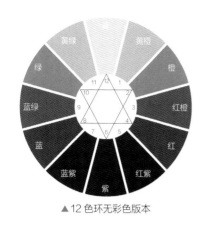

▲ 12 色环无彩色版本

色的明度级别是不一样的。例如，位于 12 点钟方向的黄色明度级别较高，那么添加一点水分就可以接近白色了，而位于 6 点钟方向的紫色本身明度级别较低，很暗，它需要添加很多水才能趋近白色。反之，黄色需要添加很多黑色才能接近黑色，而紫色只需要添加一点点黑色就可以趋近于黑色了。

小贴士

这个无彩色的色环同时也揭示了颜色的"存在感"的强弱。水彩纸是白色的，这时紫色及其附近的颜色（下半圆）在白纸上的存在感很强，黄色及其附近的颜色（上半圆）存在感很低，因而，在进行叠色时，下半圆的颜色很难被其他颜色覆盖住，而上半圆的颜色则很容易被其他颜色覆盖住。

如何调色

前面介绍了色相、饱和度、明度的调节逻辑，但是在实际操作中，我们不需要记住哪个颜色加哪个颜色等于哪个颜色，只需要根据颜色的各项属性去调出自己想要的调子。

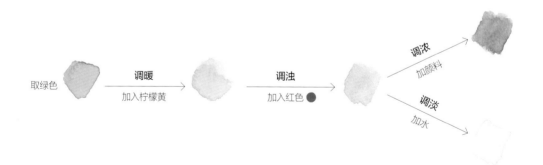

（1）根据色相调色

颜料盒里大概分绿色调、红色调、蓝色调、黄色调等这几类颜色。假如现在想要一个比较绿的颜色，那么眼睛就会首先瞄准颜料盒里的几个绿色作为初始选择，而不会去找红色或其他类型的颜色。这是一个很直觉的行为，这一步相信大家都比较容易理解。后面根据其他调子去调色，始终是服务于绿色的，也就说，绿色是主体，绿色量占比 50% 以上。

小贴士

当然这和每个人的习惯也有很大关系，有些画家习惯一开始就用黄色和蓝色来得到不同的绿色。

（2）根据冷暖调调色

如果你想调出一个暖调的绿色，那么在瞄准了绿色调的几个颜色以后，你会做什么样的选择呢？温暖的颜色有橙色、黄色、红色等，冷的颜色一般是蓝紫色系。那么就往绿色里加点柠檬黄，就会得到一个温暖的黄绿色或嫩绿色。

小贴士

在绿色色相的几个绿色里也是分冷暖的，例如翠绿相对霍克绿要冷，所以如果上一步选择了偏冷的绿色，那么这一步暖调的颜色比例要更多。

（3）根据清浊调调色

如果觉得调出的黄绿色有些刺眼，放在白纸上明晃晃的，想颜色沉稳一些，那么就是想让它浊一点，这里涉及改变颜色的彩度，绿调的颜色里加入一点红色，将其调浊，颜色就没有那么晃眼了。

小贴士

在上一步，如果在选择温暖的颜色时选择了少量橙色或红色，那么调出来的暖绿色也许就是符合心意的绿色。

（4）根据深浅调调色

深浅调其实就是明度，如果觉得调出的颜色有点深，可以加一点水将颜色调淡。如果觉得调出的颜色太淡了，可以加入更多的颜料将颜色调浓。

总之，调色是一个动态平衡的操作，色彩很丰富多样，不局限于固有的调色规则，而是根据调子去调色，才能更容易地调出漂亮的色彩。

学会观察色彩

要学会画画，必须学会观察。而生物的"恒常性"在我们观察物体时会影响我们对于物体的形状和色彩的感知。

色彩恒常性

了解色彩的恒常性之前，我们先要了解大脑的既有认知，即大脑在日常生活中获得的经验，我们会确信不疑。例如：苹果是红色的，橙子是橙色的，树叶是绿色的，白色的花朵是白色的等。

色彩的恒常性是指当所视物体受环境光影响其表面颜色的时候，我们仍认为该物体的颜色保持不变的知觉特性。简单来说就是我们的大脑影响着眼睛判读色彩：眼睛直接观察得到的颜色，会被大脑的既有认知否决。

例如，白纸的固有色是白色，它在白色光源下呈现本色；而在黄色光源的照射下，靠近光源的一端呈现黄色。

▲ 白纸在白色灯光照射下　　▲ 白纸在黄色灯光照射下　　▲ 白色花朵在白色灯光照射下　▲ 白色花朵在黄色灯光照射下

同样地，我们把固有色是白色的花朵置于这两种光源下，能看到右边黄色灯光下的白色花朵的花瓣变成了黄色。但在实际绘画中，尤其是在写生中，我们往往容易忽略环境的影响，依然把花朵画成白色的，因为大脑告诉我们：这是白色的花朵！

小贴士

语言在色彩的恒常性中也发挥了很大的作用：语言赋予了物体名称，大脑凭借"白色花朵"这个名称，对物体进行快速识别和记忆，这就是语言在起作用。它会影响很多初学绘画的人，面对洁白的花朵和手边五颜六色的颜料，会感受到自相矛盾的冲击。这时我们应把语言和大脑暂时放在一边，转而以眼睛为主导，眼见为真。

固有色、光源色、环境色

下面引入 3 个概念，帮助我们在绘画时应对色彩恒常性，它们是**固有色**、**光源色和环境色**。前者可以理解为物体本色，后两者可以简单理解为环境光线。我们描绘的物体处于特定的空间中，或许是自然界，或许是室内，该物体都会受到周遭光线的影响，从而影响物体表面所呈现的颜色。每次观察时，都要注意光线对物体产生的影响。

（1）固有色
固有色是物体在正常光线下呈现出来的本身具有的颜色。
（2）光源色
物体在不同光源照射下，呈现出来的亮部的颜色即光源色。物体在暖光中，亮部呈现暖色，暗部呈现冷色。
（3）环境色
周围环境所呈现出来的颜色即环境色，例如邻近物体所反射出来的光线。

▲ 光源色和环境色对固有色的影响

左图中这棵山茶处于自然光之中，观察一下照片中左上角的叶片，其固有色是绿色，背对阳光，颜色偏暗，这是受到光源色（太阳光）的影响；而受环境色影响，花朵的红色反射到叶片上，在叶片靠近花朵的一侧呈现红色调。在调色时，为表现这个区域，就需要叠加红色颜料。

从大自然中学习色彩的搭配

"大自然永远是对的。"学习水彩花卉绘画时，在描绘大自然的同时，要不断汲取自然的配色智慧，并将这些智慧运用到画作的创作中。花卉绚烂多彩，给人的感觉却都非常协调，我们要在多种多样的色彩搭配中找到均衡色彩的秘密。

图中所示是公园中常见的粉色和红色的美人蕉，观察可发现它们不只是花朵颜色不同，各自花朵与叶子之间的颜色搭配也不同。

大自然中看似平常的花朵，蕴含着无限的智慧，也正是大自然如此精妙的色彩搭配，才使得我们在观赏时产生美的感受。只要仔细观察自然中的花卉，我们就能找到和谐的配色法则。

▲ 粉色美人蕉

粉色美人蕉的花朵是淡粉色，花蕊部分带有珊瑚粉和橘黄色调，花瓣和花蕊的颜色是一组和谐的类似色。而花朵的色相、明度、饱和度又完全和浅蓝绿色的花萼、叶子互补：粉红色相与蓝色色相互补，中高明度的花朵和中低明度的叶子互补，中高饱和度的花朵和中低饱和度的叶子互补。整体给人温柔可人、活泼明快的感觉。

小贴士

什么是色感？

色感是指对色彩的感知力。不同人的色感是不同的，这跟每个人的生理差异以及后天经历有关系。色感是带着情感的，是流动的，每个人在画同一个景象时，感知到的颜色是不一样的。通常来说，对颜色越敏感的人，能感知到的色彩就越多，例如同一片叶子，有的人看到两三种颜色，有的人能看到数十种颜色。看到的颜色越多，能表达出来的层次就越丰富，同时表达者也更容易挑选自己想要的色彩作为媒介。

▲ 红色美人蕉

红色美人蕉，花瓣与花萼之间是一组橙红－红－红紫的类似色，而花朵的色相、明度、饱和度也完全和绿色的叶子互补。整体给人神秘高贵、热情似火的感觉。

水彩基本技法

- 干画法
- 湿画法
- 其他技法

干画法

▲ 平涂

平涂

平涂是水彩最基础的技法，直接蘸颜料平涂均匀即可。均匀的单色能产生有节律的纯色美感和扁平的形式美。平涂虽然看起来很简单，但要均匀地平铺颜色，需要提前调配好足够量的单一种颜色，避免中途颜色不够而花费时间重新调色，导致铺色不均。在面积较大的区域平铺颜色时，使用大的笔头或平头刷能更均匀地上色。

平涂时容易出现的误区有两种：一是平涂出现水痕，原因是水太多；二是平涂出现笔痕，原因是笔太干燥，笔锋太硬，力度不均。

▲ 平涂出现水痕　　　▲ 平涂出现笔痕

叠色

叠色是指在上色过程中，先涂一层颜色，待这层颜色干透后再叠加另一种颜色。层层叠加颜色可以得到逐渐加深又富有变化的颜色。同色系颜色叠色可以得到明度更低的同色系颜色，邻近色叠色可以改变色相，补色之间叠色则会降低原色的饱和度。

▲ 蓝绿叠加

（1）叠色的应用

1 调整色彩。叠加单个颜色可以调整色彩。在底色上直接叠加单一颜色可以降低颜色明度，调整色相。

▲ 在画好的花苞上叠加浅橘粉色，花萼上叠加浅黄色，得到最右侧的图

2 **表现明暗。**叠加单色可以区分明暗。通过不断加深暗部能强化物体结构和明暗关系。

▲ 在仙人掌暗部叠加同色系的低饱和度色，能让明暗关系更明显，使物体更有立体感

3 **表现斑驳色块。**用叠色技法画花叶植物的色块纹理，从最浅色的底层颜色开始，慢慢往上叠色，达到不同深浅色块的效果。

▲ 花叶常春藤叶片纹理叠色

4 **表现纹理脉络。**叠加线条在表现花脉和叶脉中经常使用，拉线方向根据纹理走向而定，拉线时需要使用聚锋性好的勾线笔。

▲ 银杏叶叶脉线条叠色，叠加的线条成放射状 　　▲ 康乃馨花瓣上的粉色线条叠色

小贴士

拉线用笔时要注意避免水太多或太用力，拉出太粗的线条；也要避免水太少，拉出断续的线条。

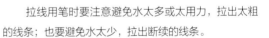

◀太粗的线条（上）和断续的线条（下）

（2）叠色常见误区

▲ 底色未干时进行叠色，造成混色

▲ 底色颜色过深进行叠色，带走底色

柔化边缘

柔化边缘是指把颜色边界虚化至透明的技法。在操作时需使用柔软而富有弹性的笔毛，每次柔化时蘸取清水，使笔头湿润。这个技法常用于颜色的过渡，减轻色块边缘感，给人细致柔和的感觉，是花卉题材的常用手法。

▲ 单方向柔化边缘　　　　▲ 向四周柔化边缘

（1）颜色深浅对柔化边缘技法的影响

对深色进行柔化边缘要比对浅色进行柔化边缘难度大。原色颜色较深时，柔化边缘的颜色明度的级数跨度大，容易冲撞出水痕或使柔化不均匀；而原色颜色较浅时，柔化边缘的明度级别跨度小，相对容易进行柔化边缘的技法操作。在对大面积深色进行渐变处理时，可使用湿画法，更易操作。

（2）纸张的纹理和画笔材质对柔化边缘技法的影响

细纹水彩纸由于吸水性更强，在柔化边缘时比粗纹水彩纸难把握效果；松鼠毛笔相对人造纤维毛笔柔软，更容易柔化边缘。

（3）柔化边缘常见误区

▲ 上一遍颜色太干，出现明显分界线　　　▲ 笔头水分过少，出现吸色情况　　　▲ 柔化次数不够多，边缘不消失

接色

接色也是常用的水彩技法之一，指把两个或以上的颜色衔接在一起，达到颜色变化的效果。在接色前应预先调配好需要衔接的两个颜色，给自己充足的时间进行接色的动作。

▲ 两个颜色接色

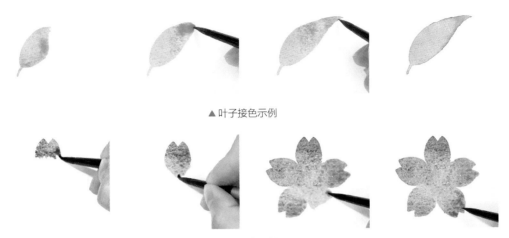

▲ 叶子接色示例

▲ 花朵接色示例

接色常见误区有两种：一是出现水痕；二是出现明显分界线。

（1）出现水痕

在接色时，如果两个颜色的水量不均衡，水分多的颜色会往水分较少的流动，从而冲刷出水痕。

▲ 左侧颜色水分明显多于右侧的颜色，从而冲刷出水痕

（2）出现明显分界线

在上完第一个颜色后才开始调第二个颜色，等上第二个颜色时，第一个颜色已经半干了，就会出现明显的分界线。所以接色前要预调好所需要的颜色，在上一个颜色湿润时接色。

▲ 左侧半干的颜色接色后出现明显的分界线

湿画法

以上几个技法都是在纸面干燥的情况下进行的，都属于干画法。下面介绍在纸面湿润的情况下进行的上色技法——湿画法。在纸面湿润的时候，我们可以铺色、混色、点染、接色晕染、控制颜色流向、修改塑形等。

混色

混色是指先把纸面用排刷铺湿或用喷壶喷湿，之后在纸面湿润的状态下不断加入颜色，使其混合在一起。常用的混色方法有湿接法和湿叠法。下面，我们分别用湿接法和湿叠法对花瓣进行混色。

（1）准备工作

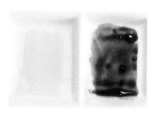

▲ 调出两个需要用到的颜色

▲ 用清水把花瓣区域铺湿

（2）湿接法

▲ 在区域左侧涂上黄色

▲ 右侧接上棕色

▲ 完成湿接

（3）湿叠法

▲ 用黄色铺满上色区域

▲ 趁湿在右侧叠入棕色

▲ 完成湿叠

小贴士

▲ 水分过多导致水痕

混色时笔头水分要少，如果水分过多，颜色干透后容易产生水痕。

避免水痕的方法有：
①蘸取颜色后用纸巾吸掉笔尖里的一部分水分再上色；
②选择蓄水能力不强的画笔，如貂毛笔或纤维毛画笔。

点染

点染在底色湿润的情况下进行，是湿画法的一种。常用于背景晕染，氛围塑造。在水彩花卉手绘中，局部点染可塑造特殊的植物肌理。

▲ 底色水分多时点染

▲ 底色水分少时点染

点染可应用于如下情况。

（1）表现斑点

（2）表现颜色扩散

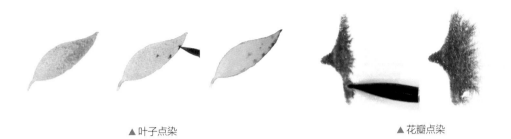

▲ 叶子点染

▲ 花瓣点染

小贴士

对比点染和柔化边缘两种技法

在表现同样的效果时，我们可以使用不同的技法，如表现花瓣的颜色渐变时，可以选择干画法（柔化边缘），也可以选择湿画法（点染）。

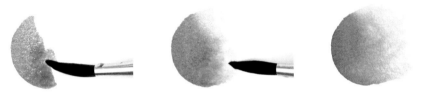

▲ 用干画法（柔化边缘）画花瓣

① **柔化边缘**。先涂色，然后柔化边缘，调整颜料范围和颜色深浅。

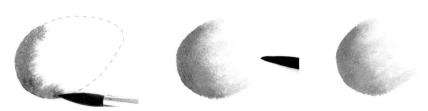

▲ 用湿画法（点染）画花瓣

② **点染**。先把需要涂色的虚线区域铺水，然后从一边开始点染，在颜料扩散的同时，用笔调整颜料范围与颜色深浅。

点水

点水是指利用清水进行点染的一种上色技法，是对底色有意进行水痕的冲刷，从而形成特殊的效果。

▲ 底色水分多时点水

▲ 底色水分少时点水

擦色

在底色半湿润的状态下，我们可以对画面进行擦色、局部修改调整等。擦色宜选择硬度较好的纤维毛笔，面积大时也可以用纸巾吸附底色。在颜色已经干透的情况下，可以对纸面重新打湿进行修改，但不宜多次修改，否则会损伤纸张。

▲ 用笔擦出线条

▲ 用笔擦出形状

▲ 用干纸巾吸色

▲ 用湿纸巾吸色

擦色的应用如下。

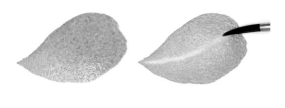
▲ 趁湿擦出花脉

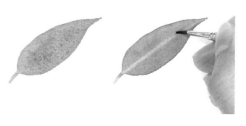
▲ 趁湿擦出叶脉

其他技法

创造特殊肌理效果

可以通过撒盐、撒白墨水、溅色等方法在画纸上呈现自然随机的点状纹理；用刮刀取色，在画纸上呈现细致的线条肌理等特殊肌理效果。

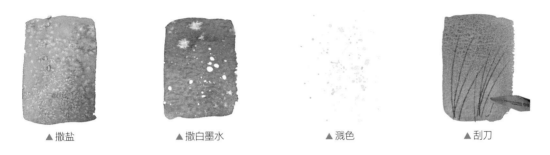

▲ 撒盐 ▲ 撒白墨水 ▲ 溅色 ▲ 刮刀

用水创造晕染效果

水彩的不确定性体现在"水"上，水把颜色扩散出漂亮的水痕，我们会得到一种流动的、富有实验性的美。在写意花卉、渲染背景、塑造特殊肌理时都会用到这种技法。

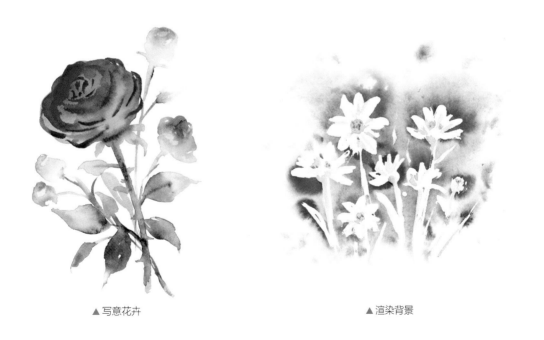

▲ 写意花卉 ▲ 渲染背景

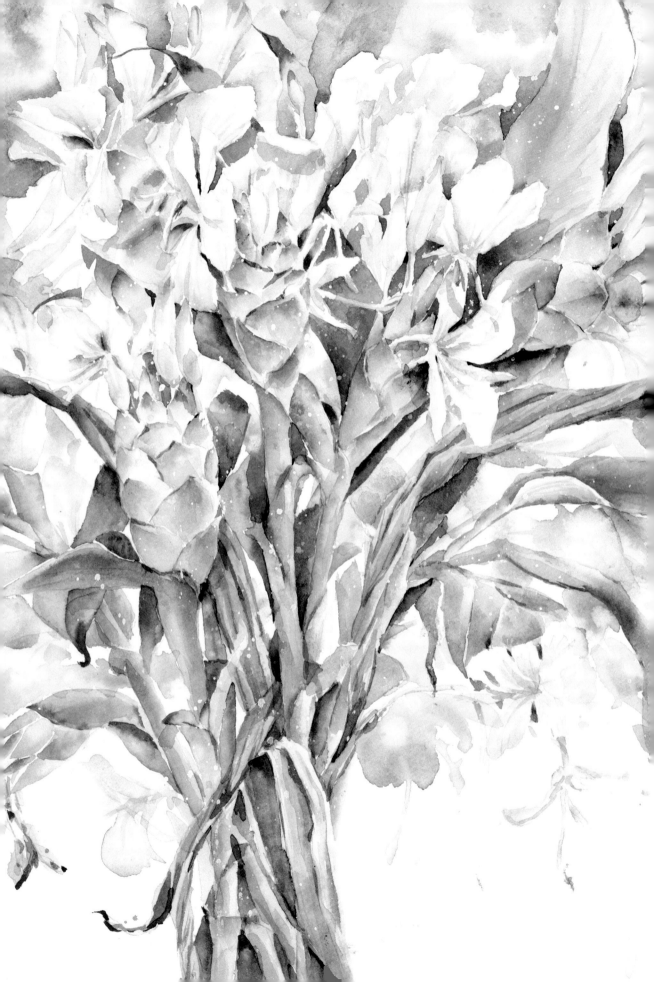

认识花卉的形态

- 花朵
- 叶子
- 茎
- 花卉的起形和透视

花朵

花朵的结构

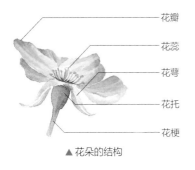

▲ 花朵的结构

花朵的形态多样，但所有的花有一个共同的结构模式，通常由花梗、花托、花萼、花蕊、花冠（一朵花中所有花瓣的总称）组成。掌握花朵的结构，对起形是十分有帮助的。

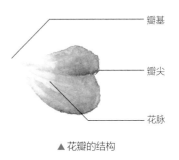

▲ 花瓣的结构

花蕊作为花朵的重要组成部分，虽然比较细小，但根据雌雄蕊排列方式的不同，形态多样，画出花蕊的层次感、体积感，能成为花朵的亮点。

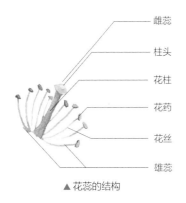

▲ 花蕊的结构

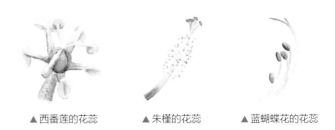

▲ 西番莲的花蕊　　▲ 朱槿的花蕊　　▲ 蓝蝴蝶花的花蕊

花冠的类型

花冠是一朵花中所有花瓣的总称。花冠按花瓣是彼此分离还是全部或部分联合的，分为离瓣花冠和合瓣花冠。常见的花冠类型如下。

（1）离瓣花冠

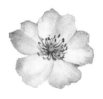

① 蔷薇形花冠。花瓣 5 片或更多，分离，呈辐射对称排列。如野蔷薇、桃、杏、梨、梅、樱花等。

② 十字形花冠。4 出数离瓣花冠，排成辐射对称的十字形。如油菜花、二月兰、紫罗兰等。

③ 蝶形花冠。由 1 枚旗瓣、2 枚翼瓣和 2 枚龙骨瓣共 5 枚花瓣组成。常见于各种豆科花卉，如紫藤、刺槐、刺桐等。

④ 石竹形花冠。花瓣 5 片，各瓣有宽阔的舷与狭长的爪，舷与爪几成直角，爪皆隐藏于萼筒内。如石竹等。

（2）合瓣花冠

① 钟形花冠。合瓣花冠、冠筒短而粗、周边向外翻卷、形状如钟。如风铃草、桔梗等。

② 轮状花冠/辐状花冠。合瓣花冠的裂片平展，呈辐射状排列，花冠筒极短或无。常见于茄科植物，如番茄、蓝花茄、茄。

③ 漏斗形花冠。花冠筒呈倒圆锥状，向上至冠檐逐渐扩大成漏斗状。如牵牛花、打碗花等。

④ 筒状花冠/管状花冠。合瓣花，花冠联合成管状。如向日葵的头状花序中央位置的管状花、毛萼口红花、炮仗花等。

⑤ 坛状花冠。花冠筒膨大呈卵形或球形，形如罐状，中空，口部缢缩呈一短颈。如宫灯百合、蓝莓花。

⑥ 唇形花冠。花冠下部合生成管状，上部向一边张开，状如口唇，上唇常 2 裂，下唇常 3 裂。如一串红、益母草等。

⑦ 高脚碟形花冠。花冠下部合生成狭长的圆筒状，上部忽然成水平扩大如碟状。如迎春花、莺萝等。

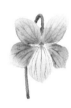

⑧ 具距花冠。花瓣向后或向侧面延长呈管状、兜状等形状。如楼斗菜、紫花地丁等。

示例 1　耧斗菜

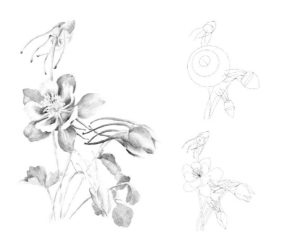

耧斗菜的花形看似复杂，但了解了其花冠结构就会发现，其观赏部分由花蕊、宽长圆形的花瓣（内圈）、窄卵形的萼片（外圈）和花瓣向后面延长成的管状的距构成。起形时把开放的花朵看作花蕊、花瓣和萼片三个圆形部分的组合体；把未开放的花苞看作是圆锥形后面带着灵动的小尾巴（距）。整体形态就会清晰很多。

花的着生方式

被子植物的花，根据着生方式可以分为单生花和花序。单生花指的是单朵花单生于枝的顶端或叶腋处，如郁金香、牡丹等。花序是指多朵花在花轴上的排列方式。常见的观花植物的花序类型如下。

　穗状花序： 长长的花序轴上着生着许多无梗或花梗很短的两性花，如车前草、穗花婆婆纳。

　总状花序： 花序轴长，其上着生许多花梗长短大致相等的两性花，如油菜花、豌豆花、风铃草花等。

　头状花序： 花序上各花无梗，花序轴常膨大为球形、半球形或盘状，花序基部常有总苞。如洋甘菊、向日葵、鬼针草、金合欢等。

　伞房花序： 花序轴较短，其上着生许多花梗长短不一的两性花。下部花的花梗长，上部花的花梗短，整个花序的花几乎排成一平面。如梨花、苹果花。

　伞形花序： 花序轴缩短，花梗几乎等长，聚生在花轴的顶端，呈伞骨状，如海棠花、石蒜花、报春花、蓝雪花、朱顶红等。

　复伞形花序： 许多小伞形花序又呈伞形排列，基部常有总苞，如胡萝卜花等。

　圆锥花序： 总状花序的花序轴分枝，每一分枝成一总状花序，整个花序略呈圆锥形，如紫薇、南天竹、凌霄等。

　肉穗花序： 花序轴肉质肥厚，其上着生许多无梗单性花，花序外具有总苞，称佛焰苞，因而也称佛焰花序，如马蹄莲、半夏、花烛、红掌、紫掌等。

　螺状聚伞花序： 单歧聚伞花序的一种，侧芽只在同一侧依次形成侧枝和花朵，呈镰状卷曲，如小苍兰等。

　蝎尾状聚伞花序： 单歧聚伞花序的一种，侧芽左右交替地形成侧枝和顶生花朵，成两列，形如蝎尾状，如剑兰（唐菖蒲）等。

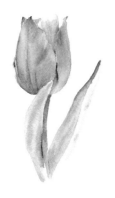

▲ 单生花：郁金香

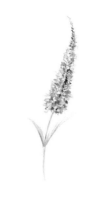

▲ 穗状花序：穗花婆婆纳

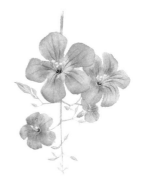

▲ 圆锥花序：凌霄花

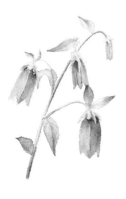

▲ 总状花序：紫斑风铃草

▲ 头状花序：鬼针草

▲ 螺状聚伞花序：小苍兰

▲ 蝎尾状聚伞花序：剑兰

▲ 肉穗花序：紫掌

▲ 伞形花序：报春花

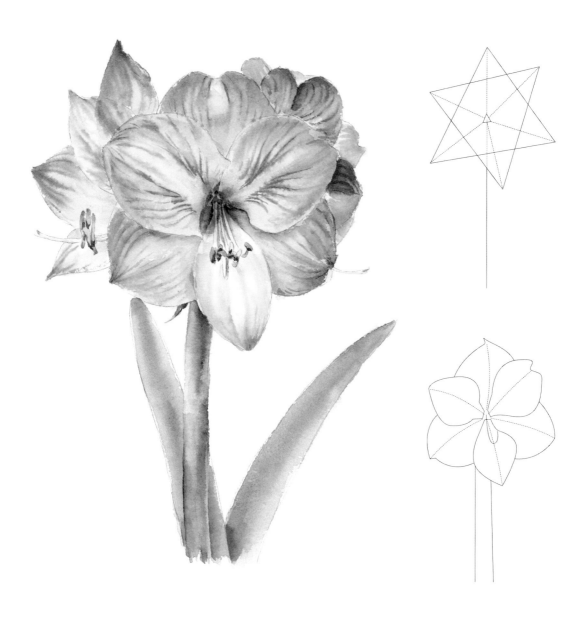

朱顶红的花序是顶生伞形花序，花序有2~4朵花，花梗近等长。仔细观察，可以发现它的6片花被片长圆形，排列上是前后各3片，起形的时候可以用两个三角形概括（一个正三角形，一个倒三角形），形成6个角，也就是6片花被片的形状，之后细化。

叶子

叶子的结构

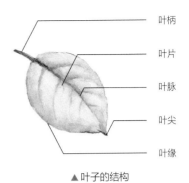

▲叶子的结构

叶子的结构分为叶柄、叶片、叶脉、叶缘、叶尖。叶片的形状各种各样，有椭圆形、心形、掌形、扇形、菱形、披针形等。叶缘的类型有全缘、锯齿、缺刻、波状、深裂等。中脉从叶柄向叶尖延伸，侧脉从中脉向叶缘延伸。

一片叶子从嫩芽发展为成叶、最后枯萎，各个阶段所呈现出来的状态是不一样的。不同植物的叶子的质感千差万别，同一片叶子的正面和反面也是不同的。叶子在水彩花卉手绘中起着重要的作用，是十分值得我们用心刻画的。

叶子的形态

同一株植物上的不同叶子有不同的形态，呈现出这些形态的变化能让画作更自然。

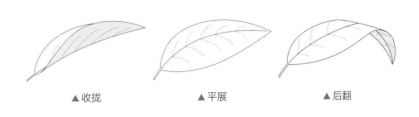

▲收拢　　　▲平展　　　▲后翻

观察角度不同，同一片叶子呈现的样子也不同，以月季的叶子为例。

▲俯视

从上往下观察，能看到叶子的全貌。

▲侧视

从叶子的侧面观察，后方的叶子会被前排叶子遮挡。

▲正视

以最尖端的叶子为前景时，后面两排叶子和叶柄都会被遮挡。随视角变化，后面的叶子有时会露出叶背。

叶序

叶序是指叶在茎上的排列形式，常见的有互生、对生、轮生、簇生等类型。准确掌握植物的叶序，才能正确地绘制出该植物。

▲互生　　▲对生　　　▲轮生　　　▲簇生

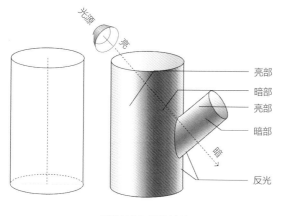

光源 亮

亮部
暗部
亮部
暗部
反光

▲ 茎的结构和素描关系

茎

茎部作为植物的支撑结构，体现了植株的整体气质。柔软细长的茎给人以优雅温柔的感觉；粗糙硬朗的茎给人以坚韧顽强的感觉。茎大体都可看作是一个圆柱体，根据圆柱体的结构和光源位置区分亮部、暗部和反光部位，可以画出茎部的立体感。自然界中没有完全笔直的线条，所以在描画茎部时不要使用尺子。

草本植物的茎是草质茎，多细而柔软；木本植物的茎是木质茎，较为坚硬粗糙；藤本植物的茎是弯曲的，依附外物攀爬，按茎的质地分为草质藤本（如牵牛花）和木质藤本（如紫藤）。

植物的茎部随着生长阶段的不同而表现出不同的质感，如月季、茉莉等植物靠近根部的茎慢慢呈现木质化特征，而新长出来的茎则是鲜嫩油亮的。

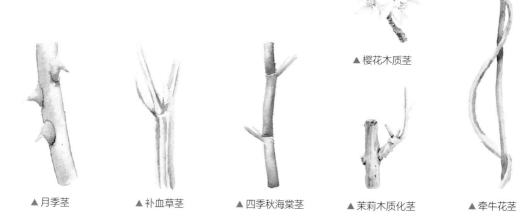

▲ 樱花木质茎

▲ 月季茎　　　　▲ 补血草茎　　　　▲ 四季秋海棠茎　　　　▲ 茉莉木质化茎　　　　▲ 牵牛花茎

花卉的起形和透视

在认识了植物的形态特征以后，我们回到最初的观察方法上：把它们看作几何体来起形。在第 2 章，我们学习了色彩的恒常性，即大脑干扰眼睛的色彩感知。下面我们来了解**大小恒常性**，它是指人对物体的知觉大小不完全随视像大小而变化，趋向于保持物体的实际大小。大脑会干扰我们，使我们画出来的物体趋向于实际形状和大小，而不符合眼睛看到的实际图像。

▲ 正确的透视

▲ 大小恒常性干扰导致出现错误的透视

起形是把三维的对象转化到二维画纸上的操作，需要掌握正确的透视方法，不然容易出现错误。

举一个例子：左图中，下方的图是受到大小恒常性干扰画出来的。画者在画之前，大脑已有的经验与认知是井口是圆的，所以下笔就把井口画成了圆形。而实际上，井口居于视平线时，是扁平的椭圆形，当其与视线齐平时，几乎压缩得呈一条线，如左图中上方的图。

同时大小恒常性还会否决我们看到的事物的体积大小，也许你有经验，在画远处事物的时候，会不自觉地把其画大了，例如把远处的高楼画得比实际看到的大很多。因为大脑觉得远处的高楼比眼前的小树要大得多，而实际作画应遵循近大远小的规则。

从上面的叙述中，我们引出了一个概念：**透视**。透视是指在二维平面上再现物体的空间感。我们常说的近大远小、近实远虚、一点透视、多点透视等都是透视的法则。不仅在画风景、建筑等题材时需要透视，画花卉类题材也需要，这里以一朵小花的起形为例浅析。

（1）正确示例

1 **画出花朵的结构**。画出花朵的碗形大轮廓，标出中心线和其他辅助线。

2 **完成线稿**。根据花瓣走向线条画出花瓣，近处的花瓣大，远处的花瓣小，两侧的花瓣显得细长。补充花蕊厚度，增强立体感，线稿完成。

（2）错误的画法

右图中花朵的结构画平了，透视关系错误，没有立体感。

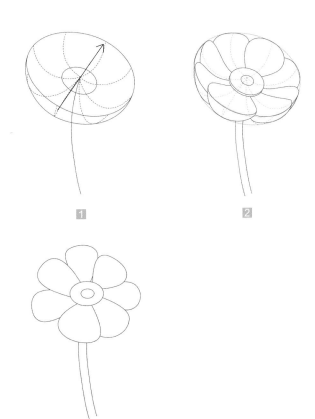

构图方法与创作技法

- 构图的基本原则
- 从点、线、面看构图
- 创作技法

构图的基本原则

构图即组织画面，把画面中的形状、空间、光影、色彩等元素组织起来，达到画面的均衡与和谐，从而产生美的感受。构图的目的是引导观画者的目光，表达创作者的内容和情感。例如当主体物处于中心时，人眼会被中心主体物吸引。

构图的基本原则是均衡。 人们喜欢安定与均衡的感觉，构图也一样。但对称和均衡不代表是数学或物理上的完全对称，而是灵活的、有张有弛的、协调的。

1 2 3

空间上的均衡

1 整支花处于画面中间位置，花朵处于画面中上部，视觉是较为均衡的。

2 花茎比较长，上下边距较小，画面两边显得空虚。

3 花朵处于画面边缘位置，左侧画幅出现大量的留白，使画面有失衡感。

主体物形体上的均衡

1 花茎自然弯曲，花朵与叶片比例协调。

2 花茎笔直，叶子对称，整体处于画面中部，给人呆板、严肃的感觉。

3 花朵较大，而叶子较小，整株显得头重脚轻。

4 花朵小，叶子占幅大，略显小气。

组合图形中的均衡

这两张图片都是均衡的，但表达的感觉却不同。图1三朵花的组合比较对称，画面饱满均衡，线

条有纪律感，三角形构图让画面有很强的稳定感，对称性显示出图案感，让人感觉庄重肃穆，有距离感。图2的三朵花组合成左下至右上的对角线分布，线条弯曲穿插，具有韵律美，花朵带有自下而上的生长方向感，花朵姿态更优雅。

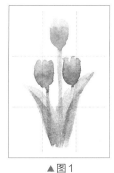

▲图1　　　　▲图2

从点、线、面看构图

构图的三要素是点、线、面。 在植物题材的绘画中，点有时是一朵花、一片叶；线有时是枝条或由点构成线条；而点和线最终构成了面，另外大面积留白也可看作是面。

前面的章节中我们了解到不同的植物有不同的形态，各有不同的美，而最好的构图方法是结合植物的形态合理地组织画面。

点

以点来呈现视觉中心。视觉中心在画面中的一个聚焦点或多个聚焦点上。

（1）一点构图

画面中只有一个聚焦点，可以第一时间把目光聚焦起来，中心点以外的元素起辅助作用。

（2）多点构图

① 三点（三角形构图）

以点为单位的三角形构图，图中三朵花视为3个点，3点形成视觉引导和循环。

② 很多规律的点（重复构图）

用重复和近似的元素在画面中平铺，形成具有规律感的图案。

③ 聚散的点（聚散构图）

画面中的花朵视为点，花朵疏密有致，有聚有散。

线

用不同形态布局的线条呈现画面的视觉效果。

（1）单线条构图

聚点成线，把花朵看作点，由多个花朵聚集成线条状，适合表现穗状花序的花朵，展示纵向延伸感。

（2）多线条构图

① 竖线上升（直线构图）

在表现向上直立生长的植物重复和近似的直立线条时十分合适。

② 竖线下垂（直线构图）

用向下的线条表现垂下来的植物枝叶状态，适合表现桉树花、柳枝等的柔美姿态。

③ 斜向的线（对角线构图）

斜线构图，也叫对角线构图，可以表现植物视觉上的立体感、空间感和运动感。画面生动、活泼。

④ 散射的线（辐射式构图）

辐射式构图，视觉冲击力强，能表现植物向外扩展的方向感。适合表现花束。

面

点、线的聚集最终构成了面，在画面中能看到点、线、面三元素，三者相辅相成。

（1）满屏构图

在表现茂密花丛时常用到的构图方式，画面中花朵和叶子作为聚散的点，枝条作为线，形成了满屏的画面。

▲ 夹竹桃　　　　　　▲ 铁线莲

（2）留白（半屏构图）

有时候适当的留白可以增加画面的透气感和花丛的生长感。

▲ 鸳鸯茉莉　　　　　　▲ 铃兰

创作技法

（1）使用他人素材进行创作

网络上或书本杂志上有很多漂亮的素材，但这些素材不能直接使用，需要注意版权问题。

（2）自己摄影取材后进行创作

日常生活中，我们经常会遇到一些漂亮的花卉，比如花瓶里的鲜花、自己栽种的花卉，或是在路边看到的小野花，这些都是很好的创作素材。在日常生活中要培养拍摄、积累素材的习惯，通过自己摄影的方式取材后进行创作，这样既能掌握自己想要的构图，还能避免版权问题。

拍摄素材时可以调出相机的九宫格，按照上一小节提到的构图方法，拍摄照片。拍摄时注意选择主体物的角度和拍摄的时间。

右侧这两张照片是组合类型的虞美人，不同的组合方法会形成不同的视觉感受：左边的组合采用一点构图，把三朵花聚在一起，形成一个聚焦点，视觉中心集中；而右侧的组合采用的是三点构图（三角形构图），三朵花即3个点，形成一个稳定的三角形。

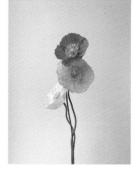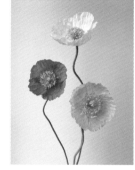

▲ 采用不同构图法拍摄的虞美人

① **拍摄素材的角度**。应选择最能体现花朵特征的角度进行拍摄，例如右侧这个例子中，矮牵牛和大花木曼陀罗的花冠都是漏斗形，但是由于矮牵牛向上开放，大花木曼陀罗下垂开放，为了表现它们各自的特点，拍摄的角度也相应进行了调整。

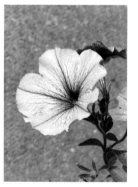

▲ 矮牵牛（左）和大花木曼陀罗（右）

② **拍摄的光源**。如果是以自然光为主光源，有太阳光直射会比没有太阳直射时拍摄的照片色彩更加鲜明，明暗关系更加明确。另外正午时分的阳光比较强烈，晨昏的阳光比较柔和；傍晚的色温偏暖，早晨的色温偏冷；夏天的光线较强烈，春秋的光线则柔和一些。这些都会影响画面的呈现效果，可根据自己想要的光源效果选择拍摄时间。

▲ 没有太阳直射（左）和有太阳直射（右）的朱槿

③ **重组素材**。重组素材就是将拍摄好的照片进行二次加工，可以调整素材的结构（删减或新增），重组后再进行绘画的创作。对电子素材进行重组时，可借助 PS 软件处理。如果是实物的照片、纸张，则可以用剪刀裁切拼接。一些较为简单的重组可以在脑海里完成，在水彩纸上直接按照构思打草稿，然后下笔。重组素材比较重要的一点是需要保持各个元素的光影一致性，使新加入的素材和原素材处在同一个时空之中，不出现相悖的光影关系。

下面图1和图2是同一时间拍的同一棵紫薇上不同部位的紫薇花照片，把它们拼接在一起，最终构成图3的效果。图4是最终完成的画稿，在图3的基础上又增加了虚化的花朵作为背景。

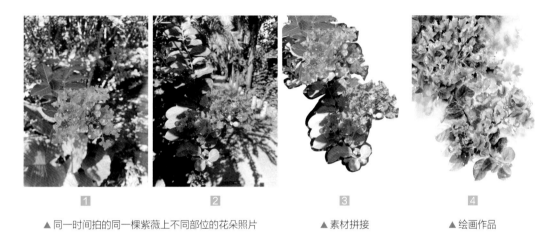

▲ 同一时间拍的同一棵紫薇上不同部位的花朵照片　　▲ 素材拼接　　▲ 绘画作品

（3）写生

除了利用摄影素材进行创作外，还可以通过写生进行现场创作。写生时，绘画者能直观地感受到三维世界中不断变化的光线以及各种动态感，多写生能有效提高抓形能力、增加创作灵感。

写生时长没有定论，在几分钟到数天之间都可以。快速的写生是速写，可以只表现线条、局部等，形式多样。写生使用的工具也不局限，各种笔和颜料均可，但写生的工具最好是精简而便携的。户外写生时多注重自己的感受，以放松的姿态下笔，这会带来更大的乐趣。

▲ 写生路边的翠芦莉

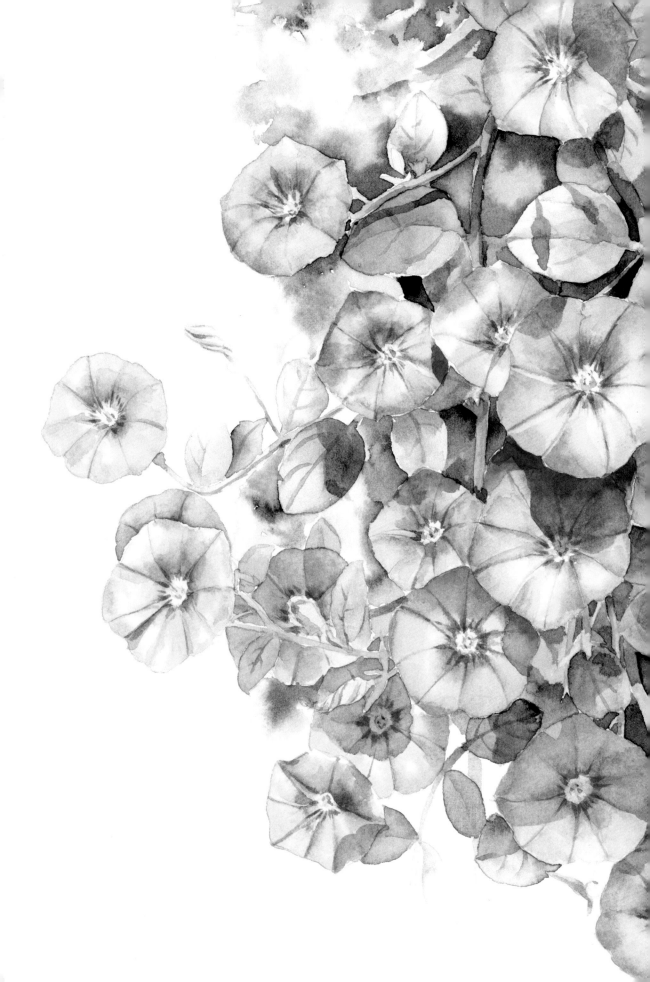

|第6章|

尝试画一朵小花吧

- 二乔玉兰
- 马蹄莲
- 朱槿
- '单提贝斯'月季
- 百子莲
- 倒挂金钟

二乔玉兰

画纸：宝虹细纹水彩纸 300g
水彩笔：竹羽堂 V18，秋宏斋 - 蒲公英
颜料：荷尔拜因植物色系 24 色
线稿：铅笔

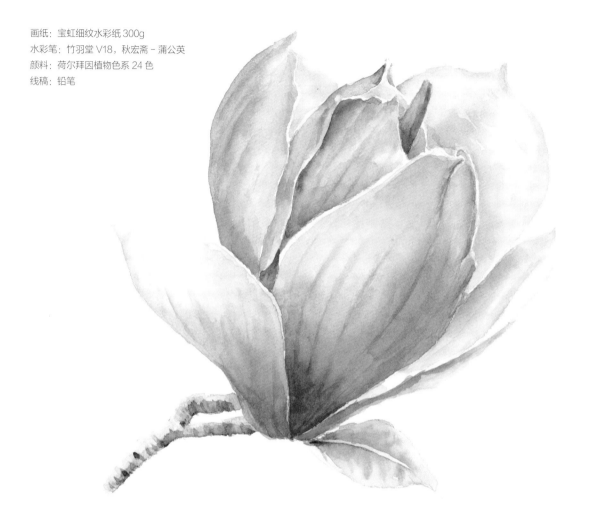

　　二乔玉兰是玉兰与紫玉兰的杂交种，与紫玉兰最主要的区别是花先叶开放（紫玉兰是花叶同放）。其花朵硕大、花香淡雅，整体给人以高贵、优雅的感觉。其寓意为纯洁的爱、芳香情思、俊朗仪态。

| W093 | W013 | W062 | W066 | W019 | W043 | W034 | W011 |
| 浅鲜青 | 歌剧粉 | 霍克绿 | 水固绿 | 朱红 | 深锡黄 | 土黄 | 胭脂红 |

1 绘制线稿

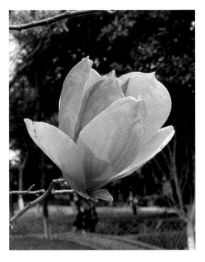

照片素材

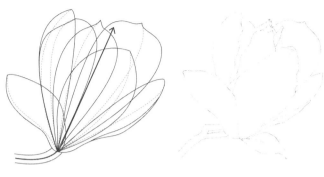

花朵的结构图　　　　　　　　　　　　　　线稿

二乔玉兰的花被片 6~9 片，外轮 3 片花被片（无法分辨的萼片和花瓣的合称）约为内轮长的 2/3。了解了花朵的形态特征，我们便可以准确地起稿，绘制出线稿。

2 花朵调色

 =

歌剧粉 + 浅群青 = **粉紫色**

 =

歌剧粉和浅群青按不同比例混合得到不同冷暖的色彩

 歌剧粉 + 朱红 = **橘粉色**

橘粉色 + 深镉黄 + 大量水 = **淡橘色**

1 观察花朵，花被片是紫红色带粉色调的。使用歌剧粉和浅群青混合，歌剧粉比例多一点，得到**粉紫色**。也可以直接用永固紫添加一点歌剧粉得到这种粉紫色。通过增减浅群青、歌剧粉的比例，可以控制颜色冷暖，使花的颜色有更多变化，更加清透活泼。

2 观察光照对花朵颜色的影响，花朵在阳光照射下会产生偏暖一点的色调，因此可以往粉色里添加朱红，调出**橘粉色**，表达暖调的感觉。当阳光落在花瓣颜色更浅的位置时，用**淡橘色**表现受光面色调。

 =

浅群青 + 歌剧粉 + 少量土黄色 = **暗紫色**

3 花朵的暗部主要是花托的位置、花瓣之间的遮挡处以及花瓣鼓起的位置。这些位置颜色最深，用冷调表达。

3 花朵上色

1 用**淡蓝色**（浅群青＋大量水）从花瓣顶端开始铺色，下接**淡歌剧粉**（歌剧粉＋水），右侧接入不同深浅的**粉紫色**，最底部颜色最深。在花瓣基部点入**橘粉色**。

2 用淡歌剧粉为第二片花瓣铺底色，底端加入粉紫色，然后趁湿用粉紫色在左边缘点入，并拉出花瓣纹理。

拉线时，末端如果出现颜色聚在一起的情况，可以用稍干的笔吸走颜色，让线条渐隐，也可以改变用笔方向，从上而下拉线。

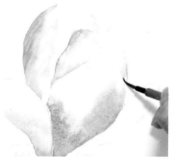

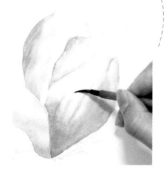

3 给中间花瓣铺水，在左边缘点入歌剧粉，留白中部，在右边缘点入粉紫色。（隔开一个花瓣不上色可避免相邻花瓣之间颜色互渗。）

4 把最大的花瓣用清水铺湿，自下而上上色，下方用橘粉色，留白左上方受光面，右上方铺粉紫色。

5 在花瓣半湿润时，用**浅胭脂红色**（胭脂红＋水）点在花瓣基部，然后使用勾线笔顺着花瓣生长方向，自下而上拉出线条，线条向上慢慢变浅、消失。

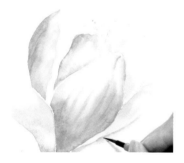

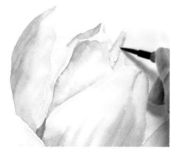

6 在左上方花瓣内侧铺淡蓝色。用淡歌剧粉画右上角的花瓣内侧的底色，留白中部的亮部位置，右下方接入淡粉紫色。用淡歌剧粉画右下方花瓣内侧的底色，在其与右上方花瓣的衔接处铺上**暗紫色**，以区分明暗；右下方花瓣外侧用橘粉色上色。

7 在中间空白的花瓣外侧用橘粉色铺满底色，瓣尖位置接入粉紫色，内侧用淡歌剧粉，注意用色上浅下深。最后一片小花瓣用歌剧粉打底，右侧暗部接入粉紫色。第一层色上色完成。

8 用胭脂红混合歌剧粉涂在最大的花瓣的基部，并往上晕开，逐渐铺湿花瓣。随后用暗紫色描画中部花脉，用歌剧粉拉出左右侧花脉。加强中部花瓣之间的层叠关系，用粉紫色加重暗部，亮部保持不变，铺水至半湿润状态，用粉紫色拉出几条线。

⑨ 加重左上方花瓣外侧的暗部色彩，用歌剧粉沿左边缘上色，至中部晕开，拉线加强花瓣纹理感。蘸取橘粉色，避开受光面，横向画出右上方花瓣的纹理，并用粉紫色加重花瓣边缘，使颜色自然晕开，表现该花瓣的纹理和光感。

⑩ 在右下方花瓣边缘叠加粉紫色。在最大花瓣左上方受光面叠加一层**淡橘色**，在花瓣鼓起的位置，也就是花瓣的最暗处，叠加暗紫色，随后用暗紫色进一步描画中部花脉。

⑪ 花朵部分绘制完成。

4 叶子及枝干调色

 = 　 = 　 =

霍克绿 + 粉紫色 = 灰绿色　　永固绿 + 深镉黄 = 嫩绿色　　霍克绿 + 朱红 = 暗绿色　　暗绿色 + 少量浅群青 = 蓝绿色

5 叶子及枝干上色

① 用**灰绿色**铺在枝干下边缘，逐渐向上柔化边缘，同时右侧点入少量橘粉色。颜料干透后，用**蓝绿色**画出枝干的木质纹理。

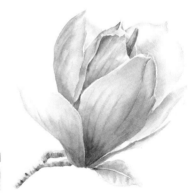

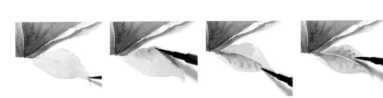

② 用**嫩绿色**铺叶子底色，趁湿在靠近花朵的部位点入少量朱红。颜料干透后，用**暗绿色**自中部往叶片两侧上色，叶脉处留白，柔化边缘。趁湿再用蓝绿色画出几道线条表示两侧的叶脉。

③ 作品完成。

马蹄莲

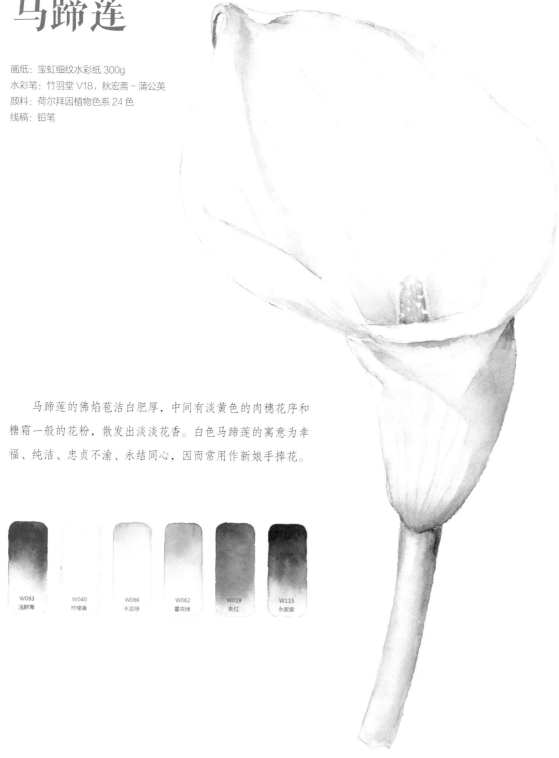

画纸：宝虹细纹水彩纸 300g
水彩笔：竹羽堂 V18，秋宏斋 - 蒲公英
颜料：荷尔拜因植物色系 24 色
线稿：铅笔

马蹄莲的佛焰苞洁白肥厚，中间有淡黄色的肉穗花序和糖霜一般的花粉，散发出淡淡花香。白色马蹄莲的寓意为幸福、纯洁、忠贞不渝、永结同心，因而常用作新娘手捧花。

| W093 | W040 | W066 | W062 | W019 | W115 |
| 浅群青 | 柠檬黄 | 永固绿 | 霍克绿 | 朱红 | 永固紫 |

1 绘制线稿

马蹄莲的佛焰苞以肉穗花序为中轴螺旋生长，边缘略向后反卷，花朵结构如同一个用纸卷起来的漏斗。根据花朵结构画出线稿。

照片素材

花朵的结构图

线稿

2 调色

花朵部分

柠檬黄 + 永固绿 + 极少量永固紫 = **暗黄色**

浅群青 + 少量朱红 = **淡灰色**

霍克绿 + 少量朱红 = **暗绿色**

柠檬黄 + 永固绿 = **黄绿色**

暗绿色 + 少量浅群青 = **暗蓝绿色**

暗黄色 + 少量朱红 = **暗橙色**

柠檬黄 + 朱红 = **黄橙色**

黄橙色 + 少量浅群青 = **暗棕色**

花梗部分

永固绿 + 霍克绿 + 水 = **淡绿色**

霍克绿 + 浅群青 = **深绿色**

深绿色 + 极少量朱红 = **墨绿色**

3 上色

1 用圆头笔避开肉穗花序，将佛焰苞区域铺满水。用勾线笔蘸取**暗黄色**自下而上逐步点染，然后柔化边缘。

2 用勾线笔蘸取**淡灰色**点染边缘位置，表现佛焰苞外翻的暗部。注意淡灰色需要有深有浅，上色时避免生硬。

3 颜料干透后，在佛焰苞区域再铺一层水，用**暗绿色**给尖部上色，下方接入**黄绿色**，然后柔化边缘。

4 趁纸面呈湿润状态时，使用勾线笔蘸取淡灰色从顶部往下轻轻拉出较虚的线条，中段较宽，首尾渐隐；待纸面变为半湿润状态后，再拉一遍细且清晰一些的线条。通过刻画暗部表现出佛焰苞表面的凹凸感。

5 用勾线笔蘸取**暗蓝绿色**勾勒出佛焰苞尖部的暗部，再蘸取**暗橙色**强化肉穗花序左侧暗部位置，并柔化边缘。

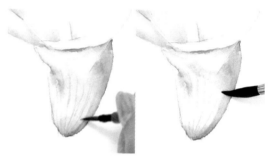

6 在花朵下半部分铺水，用暗蓝绿色点染上边缘和右侧暗部，避开中部位置，下方接入黄绿色，用暗绿色点染在右侧。继续用暗蓝绿色加重四周边缘暗部，中间暗部的位置点入淡灰色。

7 用勾线笔蘸取暗绿色，自下而上拉出线条。待画面干透后，蘸取浅灰色，于右侧叠加一层投影。

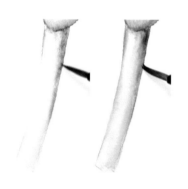

8 用**淡绿色**把花梗铺满，趁湿在右边缘点入**深绿色**，并慢慢往下带。用墨**绿色**点入右上边缘，加重暗部色彩。在左侧边缘点入暗绿色，柔化至花梗中间，中部留出高亮区域。

9 在肉穗花序的上方涂上柠檬黄，下接**黄橙色**。在左右边缘涂上**暗棕色**并晕染开。颜色干透后，用白墨水在上面点上小白点。

10 作品完成。

朱槿

画纸：宝虹细纹水彩纸 300g
水彩笔：秋宏斋 - 幽思，秋宏斋 - 蒲公英
颜料：荷尔拜因植物色系 24 色
线稿：铅笔

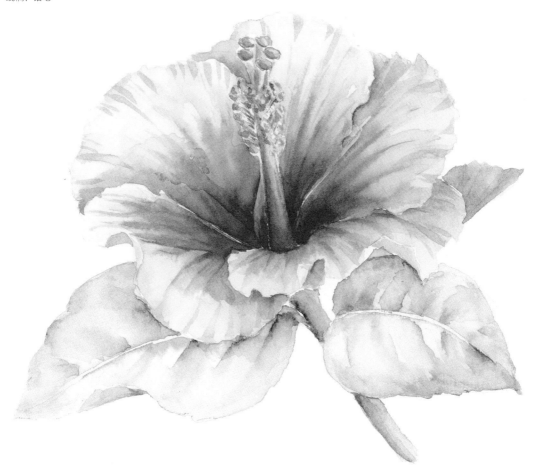

　　朱槿别名扶桑，其品种繁多，花色丰富，在我国自古以来就是
很受欢迎的观赏花卉。黄色朱槿的寓意为清新脱俗、新鲜的恋情。

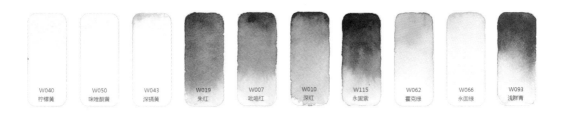

| W040 | W050 | W043 | W019 | W007 | W010 | W115 | W062 | W066 | W093 |
| 柠檬黄 | 咪唑酮黄 | 深镉黄 | 朱红 | 吡咯红 | 深红 | 永固紫 | 霍克绿 | 永固绿 | 浅群青 |

1 绘制线稿

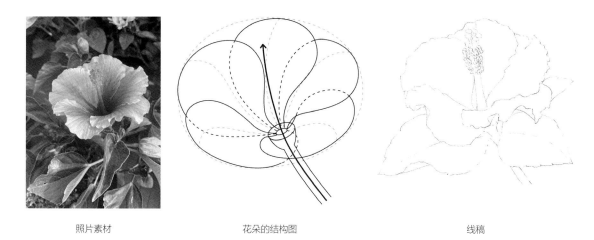

照片素材 花朵的结构图 线稿

单瓣的朱槿共有五片花瓣，以长长的花柱为轴，花朵成漏斗形张开，花瓣边缘有褶皱。花柱很长，伸出花瓣，顶端有5个火柴棒状的柱头，上半部长有细短的花丝和金黄的花药。叶子边缘呈不整齐的粗齿状。

2 花朵调色

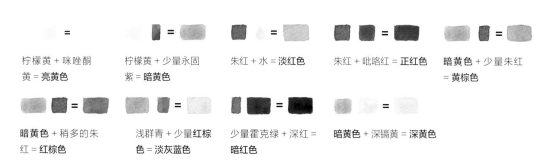

柠檬黄 + 咪唑酮黄 = **亮黄色**

柠檬黄 + 少量永固紫 = **暗黄色**

朱红 + 水 = **淡红色**

朱红 + 吡咯红 = **正红色**

暗黄色 + 少量朱红 = **黄棕色**

暗黄色 + 稍多的朱红 = **红棕色**

浅群青 + 少量红棕色 = **淡灰蓝色**

少量霍克绿 + 深红 = **暗红色**

暗黄色 + 深镉黄 = **深黄色**

3 花朵上色

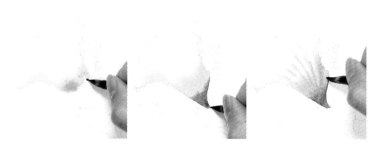

1 用清水把第一片花瓣铺湿，用调和好的**亮黄色**沿花瓣边缘向内部上色，越接近花瓣中部，黄色的明度越高，表现花瓣受光面。在左下边缘与相邻花瓣交界处接入**暗黄色**，继续往下接入**淡红色**，至花瓣基部时接入**正红色**。最后，趁湿用笔尖的余色在花瓣中部拉出若干线条，表现花脉。

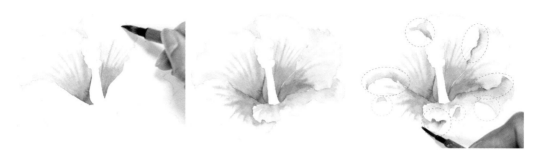

2 其余的花瓣都用步骤 1 的方法上色。待颜色干透以后，用**黄棕色**和**红棕色**加深花瓣之间的暗部（红圈位置）；把左侧和中部的蓝圈区域用黄棕色和红棕色上色，右侧的蓝圈区域用**淡灰蓝色**上底色，下边缘接入黄棕色。

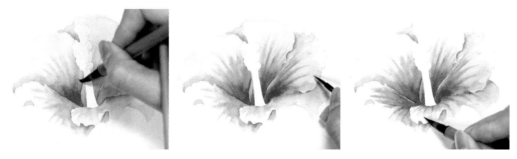

3 加重花瓣的红色部分：用清水给花瓣中部至花瓣基部位置铺水，稍晾干至半湿润状态，然后用正红色涂在花瓣基部，用笔尖拉出线条，覆盖在原来的纹理之上，让花脉有层次。五片花瓣都是如此。

4 用**暗红色**画出花柱基部的阴影。用深镉黄加重花瓣的边缘。最后用**深黄色**在花瓣边缘画出粗细、长短、间距不一的线条，表现花瓣褶皱。

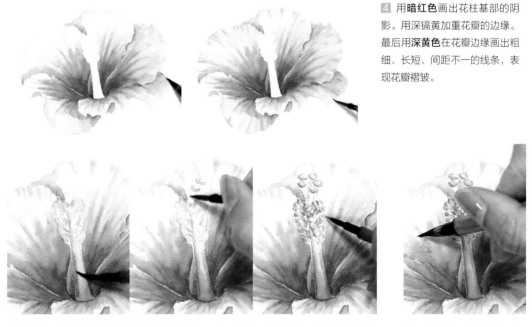

5 花柱、花丝和花药部分用**淡黄色**（柠檬黄＋水）上底色，用淡红色点入在花柱左侧，并加深左侧的暗部。上方的柱头位置用淡红色表现暗部。蘸取红棕色，用点涂的方式，点在雄蕊的暗部。

6 用暗红色加水调淡，画出花蕊在花瓣上的投影，在上部柔化边缘。

4 茎、叶调色

柠檬黄 + 永固绿 + 少量
霍克绿 = **黄绿色**

黄绿色 + 少量朱红 = **暗绿色**

黄绿色 + 少量浅群青 = **蓝绿色**

黄绿色 + 浅群青 = **湖蓝色**

5 茎、叶上色

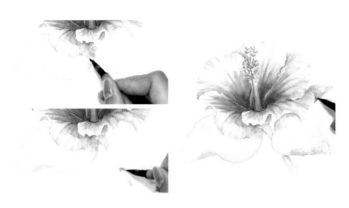

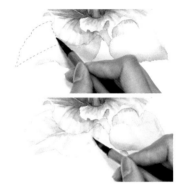

1 用水把叶子区域铺湿，避开中间，叶尖位置上**黄绿色**，叶背面上**暗绿色**，叶基部上**蓝绿色**。接着用黄绿色上花梗的底色，用蓝绿色点涂在花瓣和叶片的投影处。用同样的方法画右边的叶子。后面的小叶子的叶尖用朱红色上色，往左接黄绿色，后接蓝绿色。这样，第一层颜色就完成了。

2 待画面干透后，用清水把左侧叶子的上半部分（红圈区域）铺湿，用蓝绿色从中部往叶子上方画出叶脉线条，接近边缘的位置虚化。叶子的下半部分也是如此，注意留白中部主叶脉。

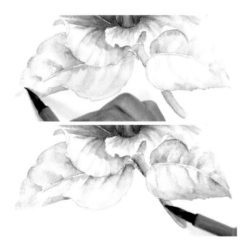

3 画面干透后，用蓝绿色块加重上半部分叶脉颜色，柔化下边缘。用**湖蓝色**加重下半部分叶脉。以同样的方法画出右边叶子的叶脉。最后用暗绿色加重花梗的暗部，用朱红点染一下叶子的尖部，平衡一下叶子的冷暖。

4 作品完成。

'单提贝斯'月季

画纸：宝虹细纹水彩纸300g
水彩笔：黑天鹅3000S #6，秋宏斋 - 蒲公英
颜料：美捷乐金装24色
线稿：铅笔

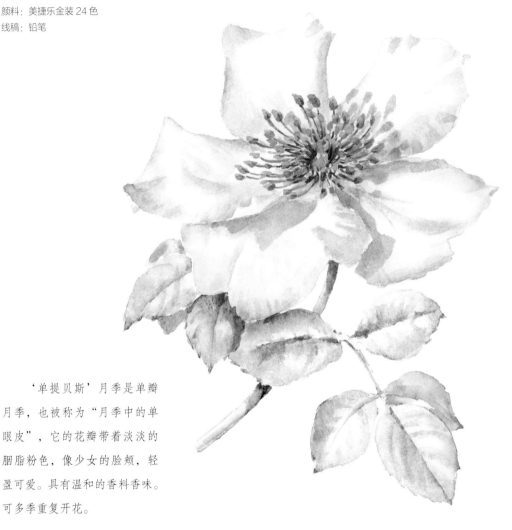

　　'单提贝斯'月季是单瓣月季，也被称为"月季中的单眼皮"，它的花瓣带着淡淡的胭脂粉色，像少女的脸颊，轻盈可爱。具有温和的香料香味。可多季重复开花。

| W551 | W553 | W518 | W523 | W545 | W564 | W534 | W513 | W536 |
| 歌剧粉 | 亮紫色 | 橘黄 | 深永固黄 | 深群青 | 熟赭 | 树汁绿 | 玫瑰茜红 | 翠绿 |

1 绘制线稿

照片素材

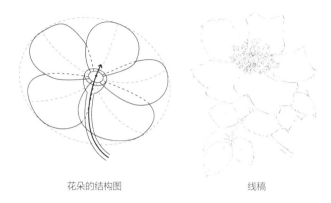

花朵的结构图

线稿

'单提贝斯'月季是单瓣月季，花瓣通常为 5 枚，分离的花瓣排成辐射状，花瓣边缘呈波浪状。

2 花朵调色

歌剧粉 + 少量亮紫色 = **冷粉色**

深永固黄 + 水 = **淡黄色**

亮紫色 + 水 = **淡紫色**

深群青 + 水 = **淡蓝色**

歌剧粉 + 少量橘黄 = **暖粉色**

歌剧粉 + 橘黄 = **橘粉色**

树汁绿 + 少量玫瑰茜红 = **暗绿色**

玫瑰茜红 + 少量翠绿 = **紫红色**

亮紫色 + 少量深群青 + 少量熟赭 = **暗紫色**

暗紫色 + 少量歌剧粉 = **暗粉色**

橘黄 + 少量歌剧粉 + 极少量亮紫色 = **暗橘粉色**

暗紫色 + 水 = **灰紫色**

3 花朵上色

1 从左往右，逐片花瓣上色：用清水铺湿花瓣，蘸取**冷粉色**沿边缘开始上色，留白花瓣中部位置，在靠近花蕊的位置接入**淡黄色**。

2 在上色时根据受光面不同接入不同冷暖的颜色：花瓣之间的边界接入**淡紫色**，上方的花瓣基部接入**淡蓝色**，左下方花瓣基部接入**暖粉色**，右下方的花瓣则更多使用淡蓝色和蓝紫色这种冷色调。

 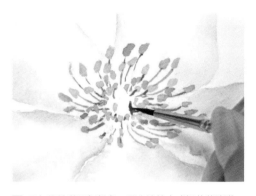

3 用淡蓝色和淡紫色进一步加强花瓣之间的阴影和边缘的褶皱。根据花瓣明度的不同，在调色时用不同的水量：花瓣中部明度较高，调色时加入的水量多一些；花瓣边缘和花瓣衔接处明度较低、颜色较重，调色时加入的水量少一些。

4 用勾线笔蘸取**橘粉色**，用点涂的方式把花药涂满，随后蘸取歌剧粉拉出线条，表现花丝。留白柱头位置，把周围用歌剧粉填满。

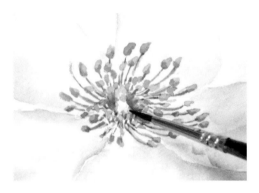 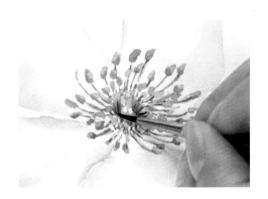

5 柱头上方涂橘粉色，下方接树汁绿，蘸取**暗绿色**点在基部。再次蘸取橘粉色，表现出花药和花丝的暗部。

6 蘸取**紫红色**在柱头的四周画出花丝的根部，用橘黄色提亮一下花药。

7 下面开始画花蕊在花瓣上的投影。根据花瓣的受光情况不同，上方投影用**暗紫色**，下方投影用**暗粉色**。花瓣之间的暗部色块也需区分：靠近花蕊处用**暗橘粉色**，其余部分用暗粉色。用调好的**灰紫色**轻轻拉出线条，表现花瓣的纹理，线条宜少不宜多，线条颜色宜浅不宜深。

4 茎、叶调色

暗绿色 + 深群青 + 少量亮紫色 = 灰绿色

熟赭 + 少量亮紫色 + 水 = 棕色

橘黄色 + 树汁绿 = 黄绿色

5 茎、叶上色

1 先用水把叶子铺湿，然后用深群青从叶尖开始上色，避开叶子中部。上下边缘涂暗绿色，上边缘较浅。中间用**灰绿色**拖出一条叶脉。

2 颜色干透后用深群青加深叶脉位置，用蘸水笔把上方颜色晕开，向上带出几条叶脉，下方也是同样操作，颜色偏淡一些。蘸取极少量的玫瑰茜红点在叶尖位置，一片叶子就画好了。

3 下方的叶子用偏暖的色调上色：先铺湿叶片，然后从左边缘用**棕色**上色，中部留白。蘸取灰绿色在中脉位置拖出一道颜色，让其晕开。右边缘接**黄绿色**。

4 颜色干透后，蘸取深群青在中部加深叶脉，之后用蘸水笔柔化边缘，并带出叶脉，上方叶脉接入一点棕色，下方叶脉接入一点暗绿色，靠近叶柄的中脉接入一点暗紫色。

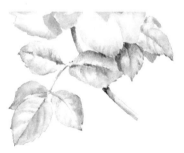

5 最后，以丰富叶子的用色为宗旨，完成其余叶子的上色。如右侧的叶子可以添加一点调色盘里的紫色调、红色调进去。叶子的暗部可以用更多的冷色调来表现。

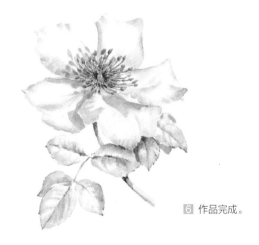

6 作品完成。

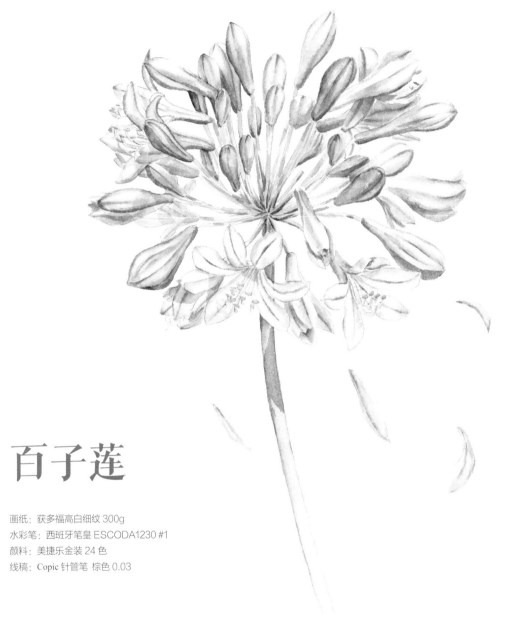

百子莲

画纸：获多福高白细纹 300g
水彩笔：西班牙笔皇 ESCODA1230 #1
颜料：美捷乐金装 24 色
线稿：Copic 针管笔 棕色 0.03

　　百子莲的盛花期在夏季，当成片的百子莲同时盛开时，蓝紫色的亭亭玉立的花球在青葱的叶子上恍如精灵一般摇曳，为夏日增添了一抹梦幻色彩。百子莲的希腊语名称是"爱之花"的意思，花语是爱情降临。

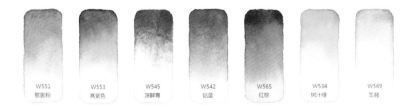

W551	W553	W545	W542	W565	W534	W569
歌剧粉	亮紫色	深群青	钴蓝	红棕	树汁绿	生赭

1 绘制线稿

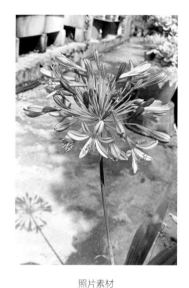
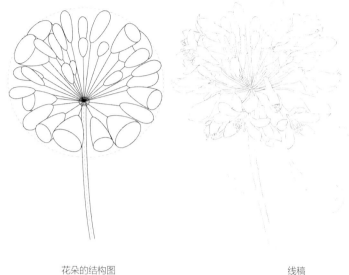

照片素材　　　　　　　　　　　花朵的结构图　　　　　　　　　　　线稿

百子莲的花葶粗壮、直立，小花在上方形成顶生伞形花序，花被合生、漏斗状，花被裂片长圆形，与筒部等长或稍长。先概括花的结构，把整个花序看成一个球体，从球心发散出花梗，末端开出朵朵小花。画线稿时，调整画面，把花球尽量画得饱满一些，将花被裂片和花蕊等细节表现出来。

2 调色

花朵、花苞调色

钴蓝 + 深群青 + 不同比例的水
= 不同深浅的**蓝色**

亮紫色 + 歌剧粉 + 个同比例的水 = 个
同深浅的**紫色**

亮紫色 + 深群青 + 不同比例的水 = 不
同深浅的**蓝紫色**

红棕 + 水 = **棕色**

歌剧粉 + 少量亮紫色 + 不同比例的水
= 不同深浅的**紫红色**

红棕 + 生赭 + 水 = **淡棕色**

花梗、花葶调色

树汁绿 + 少量生赭 = **黄绿色**

树汁绿 + 少量深群青 = **暗绿色**

深群青 + 少量黄绿色 = **湖蓝色**

3 花朵上色

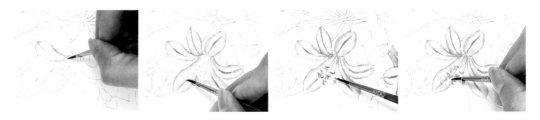

1 画朝下的花朵。先用清水把花被裂片铺湿，蘸取**蓝色**沿边缘向内上色，留白中部，花被裂片边缘用**紫色**上色，之后用**蓝紫色**拉出中线花脉。其余花被裂片用同样的方法上色，注意光源在右上方，下方花被裂片颜色偏紫。颜色干后，叠加蓝紫色，强化中线花脉的线条。蘸取**棕色**点涂在花蕊上，最后用较浅的蓝紫色画出花蕊在花被裂片上的投影。

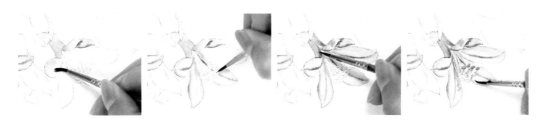

2 画朝右的花朵。花被筒的基部用紫色，上接蓝色。花被裂片、花蕊和花蕊投影的上色步骤同步骤 **1**，注意花被裂片中部是受光面，留白要多一些，这样在最后画花蕊投影的时候，影子与花瓣就会有较强的明度对比。

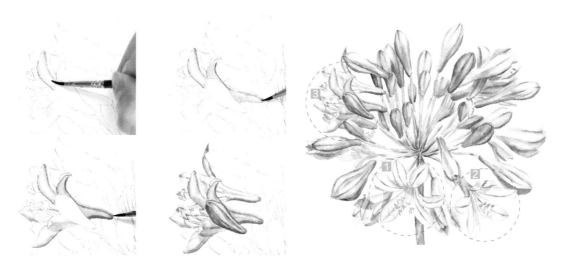

3 画朝左的花朵。左侧为背光面，画这边时要用冷一些的颜色。使用调好的蓝色，加水铺底色，用深群青画出中线花脉。右边花被筒位置的底色用紫色，注意过渡自然。花被裂片、花蕊和花蕊投影的上色步骤同步骤 **1**。最后用深一些的紫色画出下方暗部。因为花朵与花朵之间是重叠关系的，所以要注意区分好它们之间的边界，如位于前方的小花用色更重，用较深的蓝紫色表现，拉开与后方花朵的距离。

4 花苞上色

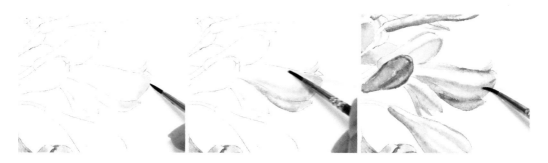

1 画半开的花苞。用水铺湿花苞，用浅一些的**紫红色**点入右侧边缘，上方受光位置留白，下方接入蓝紫色，表现暗部。颜色干透后，用深一些的紫红色加重明暗交界处的颜色。

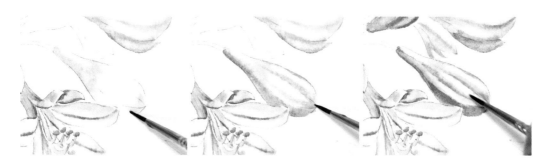

2 画闭合的花苞。右上方以及中部鼓起的位置为受光面，将其留白，左边花被筒处用紫色接蓝色，右侧末端用淡一些的紫色，让颜色自然晕开。趁湿用蓝紫色拉出几道线条，表现花苞的暗部，让颜色自然晕开。颜色干透后，再次用蓝紫色加重暗部色彩。用同样的方法画出其他闭合的花苞，可交替使用不同深浅、冷暖色调的颜色上色，使花球色彩更丰富活泼。

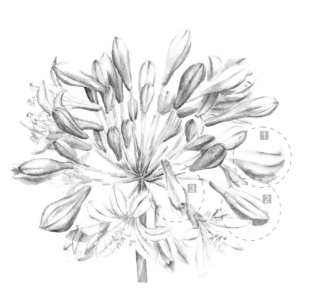

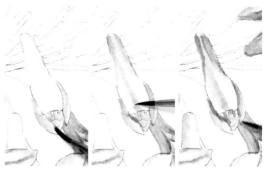

3 画朝下的半开花苞。花球上的这朵朝下的半开花苞颜色偏暖，用色以紫红色为主。用淡一些的紫色从花被筒上方开始铺色，下方颜色晕开，趁湿用紫红色加重花被筒暗部，用紫色拉出线条。用紫色给两侧花被裂片上色，留白右侧花被裂片的右边缘，左侧接入紫红色。用紫红色铺花蕊的底色，用深一点的紫色加重花蕊附近的暗部。

5 花梗、花葶上色

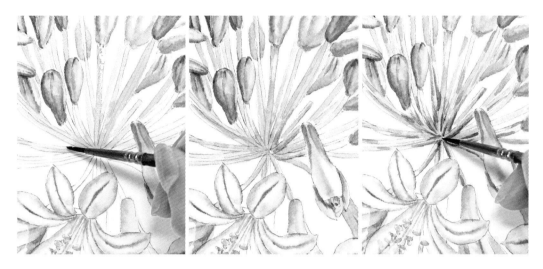

1 用**黄绿色**给花梗铺底色，用**暗绿色**表现中心位置的暗部。用**湖蓝色**画出一段段的色块，表现花朵在花梗上的投影。

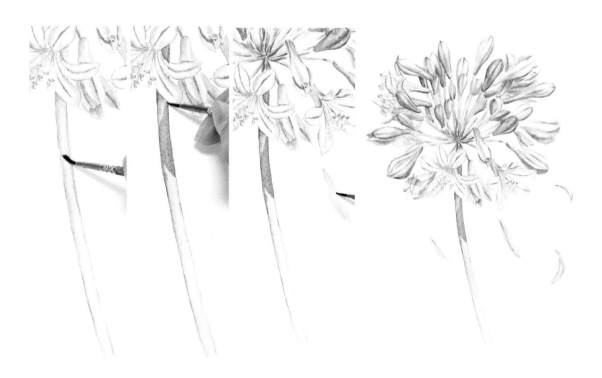

2 用黄绿色铺满花葶，趁湿在左边缘叠进暗绿色，使颜色自然过渡。干透后，用湖蓝色表现花球在花葶上的投影。最后加上飘落的花瓣：随意用调色盘里的余色上色，花瓣上可点入**淡棕色**表现枯萎的状态。

3 作品完成。

倒挂金钟

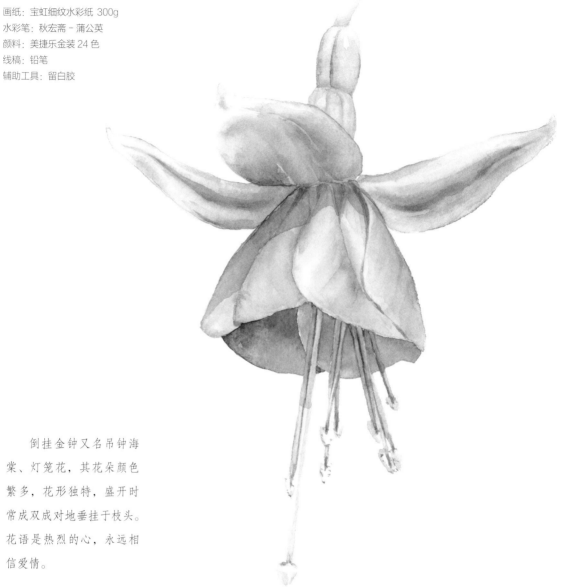

画纸：宝虹细纹水彩纸 300g
水彩笔：秋宏斋 - 蒲公英
颜料：美捷乐金装 24 色
线稿：铅笔
辅助工具：留白胶

倒挂金钟又名吊钟海棠、灯笼花，其花朵颜色繁多，花形独特，盛开时常成双成对地垂挂于枝头。花语是热烈的心，永远相信爱情。

| W535 | W534 | W518 | W536 | W545 | W553 | W551 | W511 | W541 | W561 | W564 |
| 霍克绿 | 树汁绿 | 橘黄 | 翠绿 | 深群青 | 亮紫色 | 歌剧粉 | 永固红 | 天蓝 | 赭黄 | 熟赭 |

1 绘制线稿

倒挂金钟的花筒筒状钟形，上方有 4 片萼片，三角状披针形，开放时反折。内侧的花瓣成覆瓦状排列。花蕊较长，伸出花筒，向下延伸散开。

照片素材

花朵的结构图

线稿

2 调色

花梗、花托调色

橘黄 + 树汁绿 = **黄绿色**

霍克绿 + 少量深群青 = **中绿色**

霍克绿和深群青 = **暗绿色**

花朵调色

歌剧粉 + 翠绿 = **暗粉色**

歌剧粉 + 少量永固红 + 少量橘黄 = **桃红色**

少量深群青 + 歌剧粉 = **紫粉色**

深群青 + 少量永固红 + 少量橘黄 = **蓝灰色**

永固红 + 橘黄 = **橘色**

天蓝 + 水 = **淡蓝色**

亮紫色 + 赭黄 = **深紫色**

熟赭 + 少量深群青 = **暗棕色**

3 上色

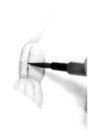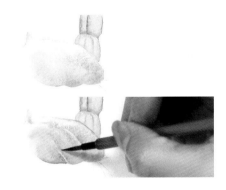

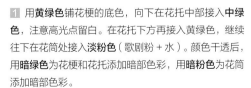

1 用**黄绿色**铺花梗的底色，向下在花托中部接入**中绿色**，注意高光点留白。在花托下方再接入黄绿色，继续往下在花筒处接入**淡粉色**（歌剧粉 + 水）。颜色干透后，用**暗绿色**为花梗和花托添加暗部色彩，用**暗粉色**为花筒添加暗部色彩。

2 画中间萼片。把萼片铺湿，在萼尖的位置点入中绿色，向下柔化边缘；中部接入淡粉色，右侧颜色更重一些，基部点入**桃红色**。趁湿蘸取**紫粉色**，在中部拉线，画出萼片中央的暗部结构。在右侧边缘点入**蓝灰色**，表现边缘暗部。

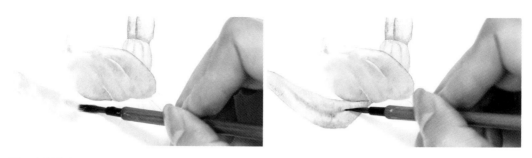

3 画左侧萼片。把萼片铺湿，萼尖点入树汁绿，向下接入淡粉色，基部接入紫粉色。趁湿用暗粉色拉出线条表现暗部。颜色干透以后，再次用暗粉色加强暗部。

4 画右侧萼片。把萼片铺湿，在基部和萼尖点入暗绿色，中部点入淡粉色，趁湿用亮紫色拉出线条表现暗部，用蓝灰色加重下方的暗部色彩并描绘出边缘。

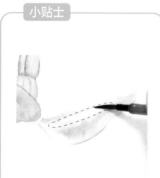

小贴士

三片萼片都是上边缘最亮，在混色的时候，如果粉色太深，可以用纸巾吸干笔尖的水分，然后用笔尖吸走多余的色彩，以留出最亮的位置，表现亮部。

5 用留白胶把花瓣前方的花蕊覆盖住，之后再进行上色：铺湿花瓣上半部分，上方点入**橘色**，四周点涂紫粉色；趁湿用紫粉色的线条画出花瓣间的边界，在空白区域点入极少量的**淡蓝色**。

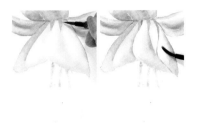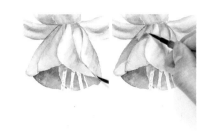

6 底色干透后，在顶部用橘色涂出小倒三角形，在每片花瓣左边缘叠加紫粉色，自然晕开，表现出花瓣的层叠关系。

7 对花瓣内部进行上色：上侧上**深紫色**，往下接入紫粉色，上深下浅。注意区分出左右两片花瓣的层次，右侧花瓣更亮一些。

8 用笔尖轻轻在花瓣上带一点浅紫粉色纹路表现花脉。用**浅紫色**（亮紫色＋水）叠加在花瓣左侧，涂出带有明确的边缘的色块，表现萼片在花瓣上的投影。

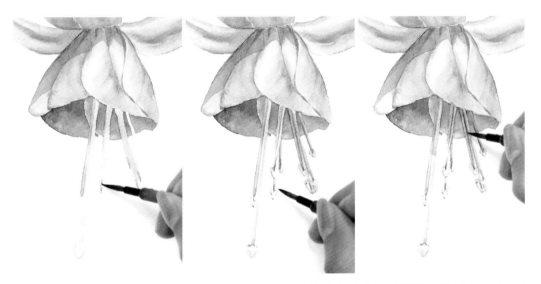

9 用猪皮擦把花蕊处的留白胶擦掉，用聚锋性好的勾线笔在雌蕊的花柱处涂上浅紫色，在雄蕊的花丝处涂上淡粉色，下方点入橘色；在柱头和花药处涂上**淡赭黄色**（赭黄＋水）；在底色干透后，用紫粉色加深花丝的左侧颜色，表现其暗部，用**暗棕色**点在花药处；最后用深一点的紫粉色加深花丝之间的边界。

10 在整个花朵的亮部（圈起来的位置）叠加一层**淡橘黄色**（橘黄＋水）表现光感。

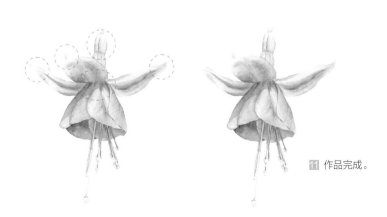

11 作品完成。

| 第 7 章 |

组合花卉

- 欧洲银莲花
- 山茶
- 牵牛花
- 铃兰
- 郁金香

欧洲银莲花

画纸：阿诗细纹水彩纸300g

水彩笔：秋宏斋－蒲公英，秋宏斋－幽思，西班牙笔皇ESCODA 1230 #1

颜料：荷尔拜因植物色系24色

线稿：百乐自动铅笔

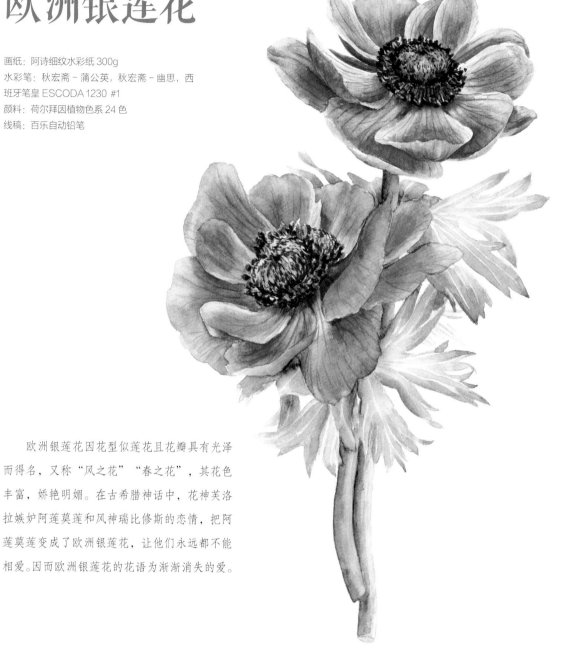

　　欧洲银莲花因花型似莲花且花瓣具有光泽而得名，又称"风之花""春之花"，其花色丰富，娇艳明媚。在古希腊神话中，花神芙洛拉嫉妒阿莲莫莲和风神瑞比修斯的恋情，把阿莲莫莲变成了欧洲银莲花，让他们永远都不能相爱。因而欧洲银莲花的花语为渐渐消失的爱。

W093	W115	W013	W066	W062	W019	W043	W034	W092
浅胭青	永固紫	歌剧粉	永固绿	霍克绿	朱红	深镉黄	土黄	天蓝

1 绘制线稿

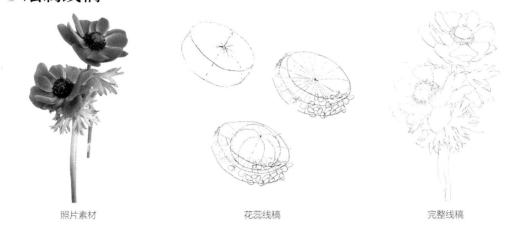

照片素材 花蕊线稿 完整线稿

欧洲银莲花的花瓣已退化，形似花瓣的观赏部位其实是它的萼片。雄蕊丝状，雌蕊的花柱不存在，柱头呈球状。画线稿时，把两朵花看作两个碗形，注意它们的朝向：一个朝左，另一个朝右。把雄蕊看作圆柱体，柱头看作球体，置于中间。之后细化萼片的轮廓和叶片的轮廓，线稿完成。

2 花朵调色

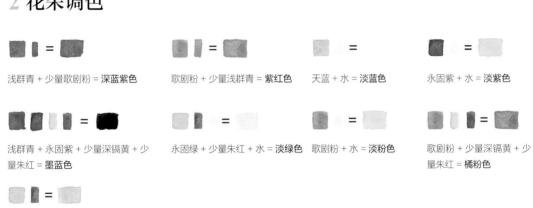

浅群青 + 少量歌剧粉 = **深蓝紫色**　　歌剧粉 + 少量浅群青 = **紫红色**　　天蓝 + 水 = **淡蓝色**　　永固紫 + 水 = **淡紫色**

浅群青 + 永固紫 + 少量深镉黄 + 少量朱红 = **墨蓝色**　　永固绿 + 少量朱红 + 水 = **淡绿色**　　歌剧粉 + 水 = **淡粉色**　　歌剧粉 + 少量深镉黄 + 少量朱红 = **橘粉色**

永固绿 + 少量朱红 = **暖绿色**

3 花朵上色

1 先画上方花朵。从左边的萼片开始上色，把整片萼片铺湿，在右侧点入**深蓝紫色**，向左逐渐过渡到瓣尖的浅蓝紫色。在上下两侧点入**紫红色**，最后用紫红色补全萼片右侧。

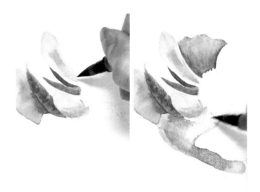 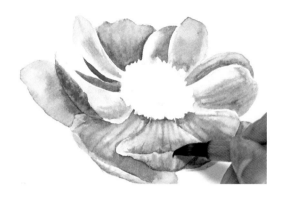

2 用湿画法逐片萼片上色。紧邻的萼片的背面用浅群青过渡到边缘的永固紫，正面用**淡蓝色**和**淡紫色**过渡，萼片尖部点入少量紫红色，让各片萼片都有冷暖变化。注意被遮挡的萼片颜色更深，因而用水更少，使用深蓝紫色表现暗部。

3 留白花蕊位置，给剩余萼片上色。萼片的固有色是蓝紫色，以蓝色－深蓝紫色－紫红色渐变为主，上色时注意处理好萼片自身以及萼片与萼片之间的明暗关系。可趁湿用深蓝紫色拉出一些线条，增强大片的萼片的细节感。

 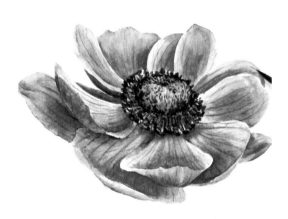

4 分别给雄蕊和柱头位置铺上淡蓝色，在柱头的上边缘混入一些淡紫色；趁湿用**墨蓝色**给柱头勾画边界，左边颜色更重一些；用浅群青在雄蕊花丝的位置，环绕柱头拉出一些线条；颜色干后，用墨蓝色围绕柱头一圈点涂，表现花药；之后选用更小的勾线笔蘸取墨蓝色，顺着柱头的结构线在上面点入小点；最后蘸取一些**淡绿色**，叠加在柱头上，丰富其颜色，这样花蕊就完成了。

5 这时萼片的颜色相对花蕊来说单薄了一点。下一步用深蓝紫色和永固紫来加深萼片的暗部，用深蓝紫色加重花蕊的投影，用深蓝紫色在萼片上拉出花脉。这朵花就完成了。

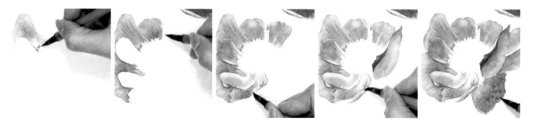

6 接下来画下方的花，上色方法跟上一朵花一样。这朵花的固有色是紫红色，上色时以永固紫－紫红色－橘粉色渐变为主。使用接色法给萼片上底色，萼片边缘用**淡粉色**，中部按照萼片的层叠关系，用不同明度的紫红色上色。个别萼片的尖部混入**橘粉色**，增加暖调。

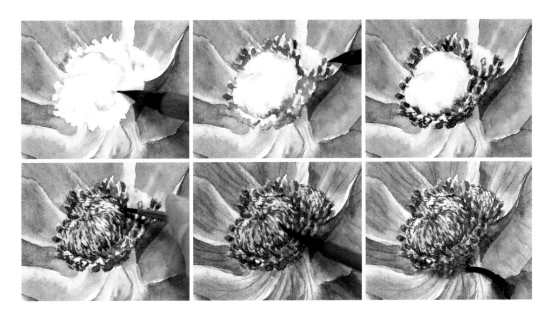

7 给花蕊上色。把柱头区域用淡绿色铺湿，周边区域点涂少量紫红色；用墨蓝色点涂在花药处，颜色干透后再叠加一次，直至颜色接近黑色为止；用勾线笔蘸取永固紫沿着柱头的结构线点上密集的点，颜色干后叠加一层**暖绿色**和紫红色，最后用深蓝紫色加重花蕊在萼片上的投影，柔化边缘。

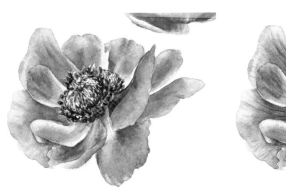

8 用永固紫加重萼片之间的暗部色彩，再用勾线笔拉出紫红色的花脉，这朵花就完成了。

4 花萼和叶片调色

朱红＋少量永固绿＝**棕色**

朱红＋少量永固绿＋少量浅群青＝**暗棕色**

浅群青＋深镉黄＋朱红＋水＝**淡灰蓝色**

霍克绿＋永固绿＋少量朱红＝**暗绿色**

霍克绿＋永固绿＋极少量朱红＝**中绿色**

永固绿＋浅群青＋少量朱红＝**暗蓝绿色**

朱红＋土黄＋少量群青＝**暗红棕色**

5 花葶和叶片上色

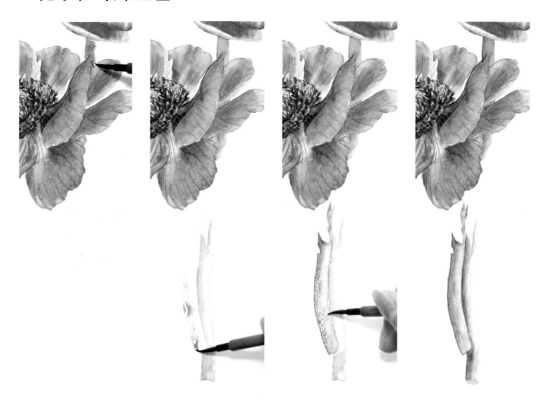

1 接下来开始画花葶。先画右侧的：用永固绿铺好底色，趁湿在左侧混入**棕色**。再画左侧的：用永固绿铺底色，趁湿在左侧混入**暗棕色**。

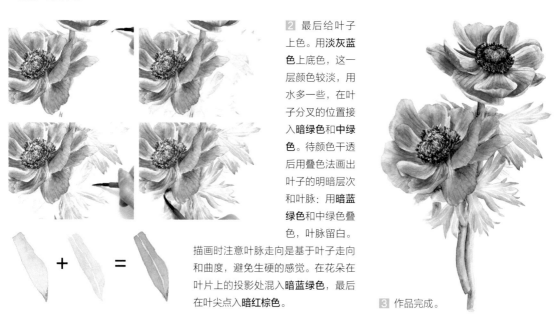

2 最后给叶子上色。用**淡灰蓝色**上底色，这一层颜色较淡，用水多一些，在叶子分叉的位置接入**暗绿色**和**中绿色**。待颜色干透后用叠色法画出叶子的明暗层次和叶脉：用**暗蓝绿色**和中绿色叠色，叶脉留白。

描画时注意叶脉走向是基于叶子走向和曲度，避免生硬的感觉。在花朵在叶片上的投影处混入**暗蓝绿色**，最后在叶尖点入**暗红棕色**。

3 作品完成。

山茶

画纸：阿诗细纹水彩纸 300g
水彩笔：秋宏斋 - 幽思，秋宏斋 - 蒲公英
颜料：荷尔拜因植物色系 24 色
线稿：Copic 针管笔 棕色 0.03
辅助工具：留白胶

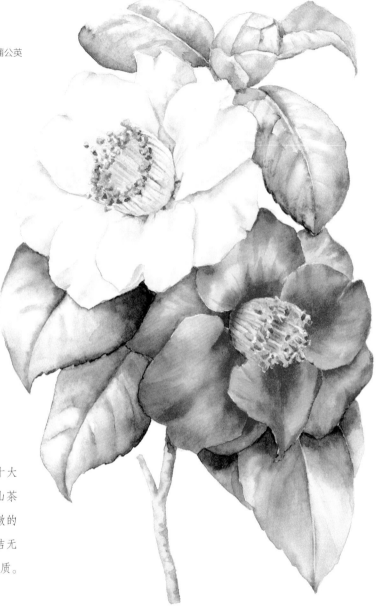

山茶原产我国，是中国十大传统名花之一，品种繁多。山茶盛开在冬春季节，因而有孤傲的寓意。白色的山茶花寓意纯洁无邪，红色的山茶花寓意天生丽质。

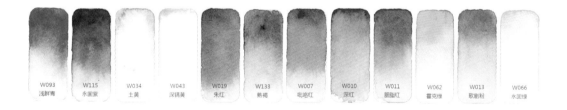

W093	W115	W034	W043	W019	W133	W007	W010	W011	W062	W013	W066
浅群青	永固紫	土黄	深镉黄	朱红	熟褐	吡咯红	深红	胭脂红	霍克绿	歌剧粉	永固绿

1 绘制线稿

山茶的花无梗，花瓣 6~7 片，外侧 2 片近圆形，几离生，内侧 5 片基部连生，倒卵圆形，比外侧花瓣长；雄蕊 3 轮，外轮花丝基部连生；雌雄蕊近等长。根据山茶的形态特征画出两朵山茶花的线稿。

2 白色山茶花调色

浅群青 + 永固紫 + 少量土黄 = **灰色**

深镉黄 + 水 = **淡黄色**

浅群青 + 少量永固紫 + 少量土黄 = **灰蓝色**

霍克绿 + 水 = **淡绿色**

少量浅群青 + 永固紫 + 少量土黄 = **灰紫色**

朱红 + 水 = **淡红色**

熟褐 + 少量浅群青 = **灰棕色**

3 白色山茶花上色

1 用留白胶把两朵花的花蕊遮盖住。先画白色的花，从左边花瓣开始，先把花瓣用水铺湿，然后蘸取灰色描绘花瓣的暗部（花瓣之间的衔接处及花瓣褶皱造成的不受光的位置），亮部留白。

2 为右侧花瓣上色，靠近花蕊的位置点入**淡黄色**，花瓣边缘点入**灰蓝色**。接着用灰色，像上一步骤一样描绘花瓣的暗部，最后用**淡绿色**点缀一下瓣尖。

3 为邻近的左右两片花瓣上色。为丰富花瓣色彩，在左侧花瓣末端接入**灰紫色**，在右侧花瓣末端接入灰蓝色。上色时，注意与先前两片花瓣衔接处保持淡色，这样能明确花瓣之间的前后层次，避免花朵的颜色过于灰暗。在接近花蕊的位置点入淡黄色。

4 继续为邻近两片花瓣上色，在花瓣衔接处点入灰紫色，表现花瓣之间的层叠关系。最后以同样的方法给最后一片花瓣上色，这片花瓣相对于邻近花瓣而言，处在上一层，因而颜色偏白，用色尽量轻淡，在靠近花蕊的位置点入淡黄色，再添加一些**淡红色**，丰富花瓣色彩。花瓣上色完成。

5 待花瓣颜色干透后，用猪皮擦把花蕊上的留白胶擦掉，开始给花蕊上色。蘸取淡黄色，涂在花蕊的侧面，下方暗部点入少量灰色；随后蘸取深镉黄，加一些水，避开花药，涂在中心处，中间位置是雌蕊，蘸取永固绿，画一条线表示一下即可。

6 蘸取深镉黄，点涂在花药的位置，点涂的时候不涂满，留出一些小缝隙；待颜色干后，蘸取熟褐同样以点涂的方式涂在每一个小花药的下方，以突出花药的体积感。

7 蘸取灰色，拉出花丝，拉线时拉至一半即可；之后蘸取**灰棕色**沿着花蕊的下边缘上色，柔化边缘，表现花蕊在花瓣上的投影。

8 继续用灰棕色在花丝位置加重，再用淡黄色强化花丝的亮部色彩，增强花丝立体感。最后用灰蓝色叠加在花蕊下方的暗部。花蕊上色完成。

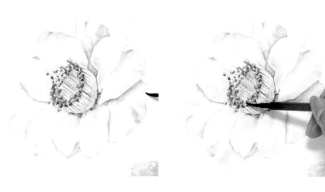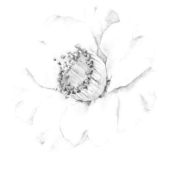

9 增加花瓣细节。蘸取灰蓝色，在花瓣上画出一些粗线，表现花脉等细节；蘸取深镉黄叠加在花药位置，增强花药的明艳度。白色花朵就上色完成了。

4 红色山茶花调色

 胭脂红 + 少量霍克绿 = 暗红色

 歌剧粉 + 水 = 淡粉色

 胭脂红 + 少量浅群青 + 深镉黄 = 红棕色

 吡咯红 + 少量朱红 + 少量歌剧粉 = 鲜红色

5 红色山茶花上色

1 铺湿每一片花瓣，逐片上色。蘸取吡咯红沿着花瓣四周点入，颜色晕开时，用吸干水分的笔头引导颜色走向，把跑到花瓣中部的颜色吸走或赶至花瓣边缘，通过留白表现亮部。同时笔锋引导颜色顺着花脉生长方向延伸，而不是任颜色四处扩散。在左侧花瓣靠近花蕊的位置点入**暗红色**。

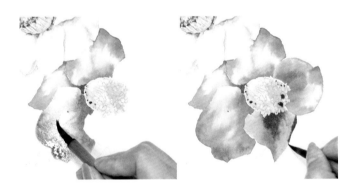

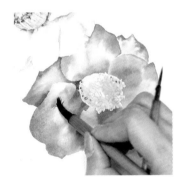

2 用同样的方法给邻近花瓣上色，注意相邻花瓣之间的颜色需要有明度区分，颜色不要混在一起。下方花瓣靠近花蕊的位置和下边缘颜色更深，用暗红色表现。

3 蘸取**淡粉色**，叠加在花瓣亮部，丰富花瓣亮部色彩。

4 蘸取暗红色叠加在花蕊四周，加强花瓣暗部色彩。蘸取灰蓝色叠加在右侧花瓣在下层花瓣的投影处（蓝圈位置）。待花瓣颜色干透后，用猪皮擦把花蕊上的留白胶擦掉。

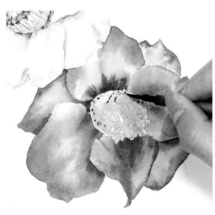

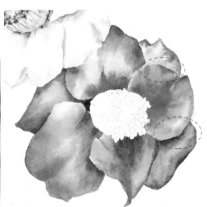

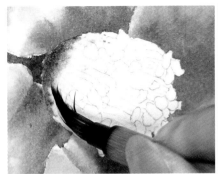 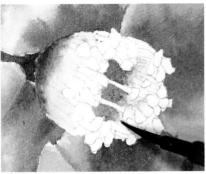

5 蘸取深红，沿花蕊左边缘上色，柔化边缘，使边缘接近透明；蘸取**红棕色**，避开中部两条花丝，表现出花蕊中间的暗部色彩，右侧柔化边缘至接近透明。

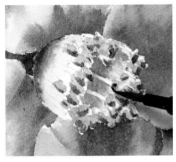 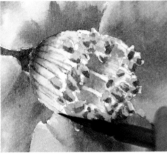

6 跟白色花的上色方法一样，使用深镉黄和熟褐点涂花药位置，随后使用深红拉出花丝，最后在花丝下方叠加灰蓝色。

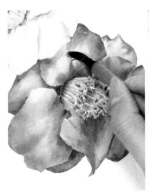 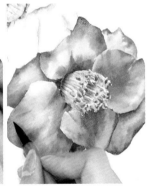

7 细节调整。蘸取暗红色，加水调淡，叠加在两朵花相接的位置上，柔化边缘，表现投影；蘸取吡咯红，加水调淡，在花瓣上拉出一些粗线条，表现花脉。最后观察画面，一些暗部用色可能有些灰暗，在这些不够鲜艳的地方叠加**鲜红色**，确保红色花朵的艳丽感。两朵花的上色完成。

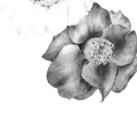
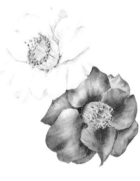

6 枝、叶调色

霍克绿 + 少量浅群青 + 少量吡咯红 = **墨绿色**

墨蓝色 + 少量永固绿 = **暗绿色**

浅群青 + 少量霍克绿 + 少量吡咯红 = **墨蓝色**

墨蓝色 + 永固紫 = **墨紫色**

深镉黄 + 永固绿 = **黄绿色**

熟褐里 + 少量浅群青 + 少量吡咯红 = **淡棕色**

淡棕色 + 永固紫 = **暗紫色**

7 叶片上色

1 用水铺湿左侧叶片，蘸取**墨绿色**沿四周上色，注意表现出叶片的锯齿，右上方颜色更重，拉出中部叶脉；趁湿点入霍克绿，再用**暗绿色**画出两边叶脉线条，晾干。

2 上方叶片干后，用墨绿色再次加重暗部和中线叶脉；之后铺湿下方叶片，用**墨蓝色**点入四周，中部留白，上部颜色较重，趁湿拉线表现叶脉。

3 蘸取暗绿色在下方叶片右侧画三道粗线，强化叶脉线条，随后柔化下边缘。蘸取霍克绿叠加在叶片右下方。

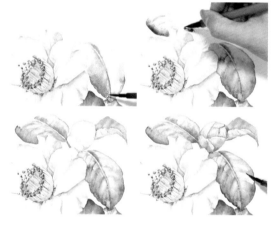

4 铺湿右侧叶片，用墨绿色画出中脉。左上方点入墨蓝色，右上方点入墨绿色，叶片下部铺暗绿色；吸干笔尖水分，对中部叶脉右侧进行吸色，自然地留出叶脉白线，用墨绿色加重叶片左边缘，右边用暗绿色；用墨蓝色拉出一些叶脉，左边缘和右边缘的亮部叠加黄绿色；位于后侧的叶片用较深的**墨紫色**上色，下接墨绿色和灰色，能够体现三片叶子前后、明暗关系即可。

5 画面上方的叶片也用湿画法逐片上色，上色时叶片和花苞的固有色更多地使用**黄绿色**和永固绿，暗部色彩以墨蓝色和墨绿色为主，亮部留白，留白不够时，可用白墨水提亮。

8 枝干上色

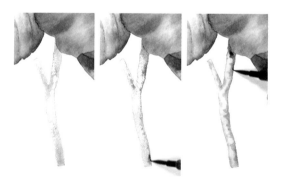 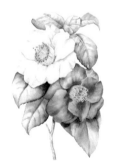

1 用**淡棕色**铺枝干底色，右侧边缘点入**暗紫色**，待颜色干后用暗紫色以 Z 形的笔触描绘右边缘，表现木质感，左边缘再次叠加淡棕色，体现立体感。

2 作品完成。

牵牛花

画纸：宝虹细纹水彩纸 - 学院级 300g
水彩笔：秋宏斋 - 松枝 小，秋宏斋 - 幽思
颜料：美捷乐金装 24 色
线稿：铅笔

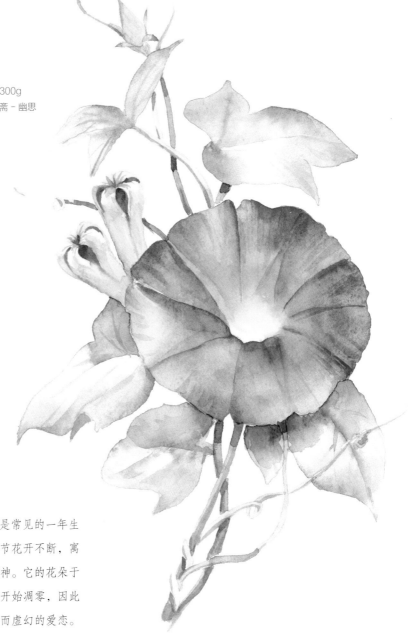

　　牵牛花俗称喇叭花，是常见的一年生
缠绕草本植物，在夏秋季节花开不断，寓
意着顽强且不屈不挠的精神。它的花朵于
每天清晨盛开，中午时分开始凋零，因此
又名"朝颜"，寓意短暂而虚幻的爱恋。

W545	W553	W551	W541	W561	W534	W535	W512
深群青	亮紫色	歌剧粉	天蓝	赭黄	树汁绿	霍克绿	永固喹啶酮玫瑰红

1 绘制线稿

牵牛花的花冠呈漏斗状，花苞尖而稍扭曲，雄蕊及花柱内藏；茎缠绕；叶宽卵形或近圆形，常3裂，先端渐尖，基部心形。

2 盛开的花朵调色

深群青 + 亮紫色 = **蓝紫色**　　歌剧粉 + 少量亮紫色 + 水 = **淡紫红色**　　歌剧粉 + 亮紫色 = **深紫红色**　　天蓝 + 深群青 + 水 = **淡蓝色**　　歌剧粉 + 水 = **淡粉色**

3 盛开的花朵上色

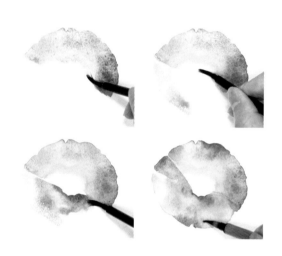

2 用蓝紫色从花瓣边缘拉线至花心，画出花瓣结构。线条用色与底色同色系，当线条靠近花心周围时，颜色换成深紫红色；线条曲度自然和谐，有虚有实，柔化边缘，自然过渡。

1 蘸取**蓝紫色**沿着花瓣边缘呈扇形直接上色，注意变化颜色，亮紫色与蓝紫色交替使用，至花心位置用**淡紫红色**上色，然后柔化边缘，使得花心是留白的；下半部分靠近花心的位置，用**深紫红色**描画边缘，往下晕开，至花瓣边缘用**淡蓝色**，再点入蓝紫色让花瓣颜色有变化。

3 颜色干透后，用水把蓝紫色调淡，画出线条表示花脉；用**淡粉色**沿花心周围叠色，增强花心的光晕感。

4 茎叶、凋谢的花朵调色

霍克绿 + 赭黄 = **黄绿色**　　黄绿色 + 少量深群青 = **深绿色**　　树汁绿 + 少量亮紫色 = **暗绿色**　　深群青 + 少量**黄绿色** = **蓝绿色**

永固啶酮玫瑰红 + 赭黄 + 少量深群青 = **红棕色**

树汁绿 + 水 = **淡绿色**

赭黄 + 少量**暗绿色** = **暗黄色**

深群青 + 少量亮紫色 + 水 = **淡蓝紫色**

深群青 + 少量亮紫色 + 少量赭黄 = **蓝灰色**

永固啶酮玫瑰红 + 少量亮紫色 = **深玫瑰红**

5 茎叶、凋谢的花朵上色

1 用**黄绿色**给藤蔓铺底色，部分枝条接上**深绿色**、**暗绿色**，让枝条有明暗变化，后方枝条用**蓝绿色**，影子的部分用**红棕色**叠上一层；上侧的花苞用淡粉色过渡至**淡绿色**，用暗粉色拉出线条。

2 给上方左侧叶片上色。用黄绿色给叶背上底色，用蓝绿色点染叶片基部，趁湿用蓝绿色拉出叶脉。

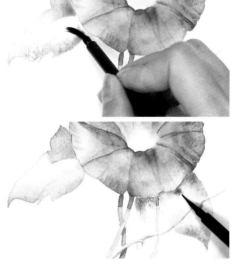

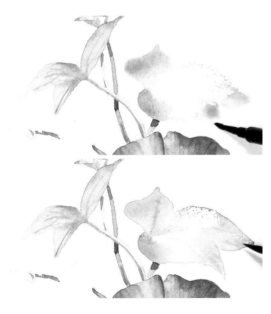

3 给上方右侧叶片上色。将叶片铺湿，避开中部区域用蓝绿色和深绿色沿四周上色；颜色干透后，再次铺湿，用蓝绿色拉出线条表示叶脉。

4 给中间两片叶子上色。用霍克绿从左侧叶片上边缘上色，至中间叶脉处为止，叶脉另一侧留白，叶尖上黄绿色（赭黄比例更多），右侧边缘接蓝绿色，自然过渡至最亮处。将右侧叶子铺湿，上端用深绿色，往下过渡减淡接近透明，叶片下边缘接入暗绿色，趁湿用深群青拉出中部叶脉。

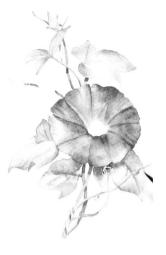

5 给最下方一片叶子上色。把叶片铺湿，左侧用**暗黄色**，右侧接暗绿色，中部留白。

6 最后给所有叶片加上淡淡的叶脉线条。叶片上色完成。

7 凋谢的花瓣会往内卷，用淡粉色给两个花朵上边缘上色，至凹陷处颜色加深；下部则用**淡蓝紫色**上色，往右接淡粉色，往上过渡至接近透明。

8 用**蓝灰色**拉出几条线条表现暗部；颜色干透后，用**深玫瑰红**填涂几块内侧的小区域，然后用蓝紫色在深玫瑰红区域的上边缘叠色，往下柔化边缘。最后用蓝灰色加重一下暗部色彩。

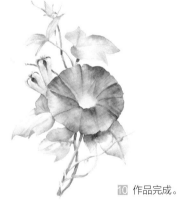

10 作品完成。

9 用红棕色淡淡地在下方的枝条叠加一层，表现老茎。

铃兰

画纸：宝虹细纹水彩纸 - 学院级 300g
水彩笔：秋宏斋 - 短锋松枝 小
颜料：美捷乐金装 24 色
线稿：铅笔

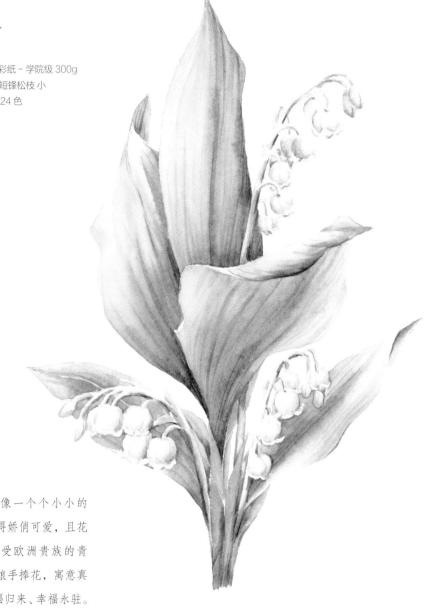

铃兰的花像一个个小小的白色铃铛，显得娇俏可爱，且花香怡人，非常受欧洲贵族的青睐，常用作新娘手捧花，寓意真挚的爱情、幸福归来、幸福永驻。

W535	W545	W541	W521	W553	W569	W513	W512	W564
霍克绿	深群青	天蓝	柠檬黄	熏紫色	生赭	玫瑰茜红	永固喹酮玫瑰红	熟褐

1 绘制线稿

照片素材

花朵结构图

线稿

每株铃兰有2片广披针形、弧状脉的叶片，基部有数枚鞘状膜质鳞片叶互抱，花葶从鞘状叶内抽出，稍外弯；花乳白色，阔钟形，下垂，裂片卵状三角形；花梗基部有披针形苞片，膜质，比花梗短。

2 调色

 =

天蓝 + 水 = 淡蓝色

 =

霍克绿 + 水 = 淡绿色

 =

霍克绿 + 少量玫瑰茜红 = 暗绿色

 =

暗绿色 + 少量深群青 = 墨绿色

 =

霍克绿 + 柠檬黄 = 黄绿色

 =

暗绿色 + 深群青 = 深墨绿色

 =

永固啶酮玫瑰红 + 水 = 浅粉色

永固啶酮玫瑰红 + 熟赭 + 少量深群青 = 暗紫色

 =

熟赭 + 水 = 淡棕色

 =

霍克绿 + 玫瑰茜红 = 棕色

 =

黄绿色 + 水 = 淡黄绿色

 =

深群青 + 极少量生赭 + 少量亮紫色 = 灰蓝色

 =

淡绿色 + 灰蓝色 = 灰绿色

3 上色

1 蘸取**淡蓝色**，从叶子左边缘开始上色，往下接**淡绿色**，到中部位置时接霍克绿，往下接**暗绿色**，到底部位置接**墨绿色**，整体是上浅下深的颜色梯度。

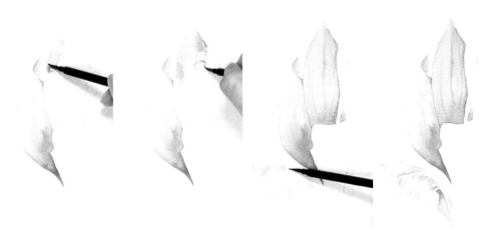

2 蘸取**黄绿色**从叶尖开始上色，右侧接霍克绿，慢慢往下接黄绿色，底端接暗绿色，最后用笔蘸取墨绿色拉几条线条。之后把下面的小叶子也上一遍底色：蘸取淡蓝色从叶尖开始上色，右边接黄绿色，中部用暗绿色。注意避开花朵进行上色，也可以使用留白胶提前覆盖花朵区域再上色。

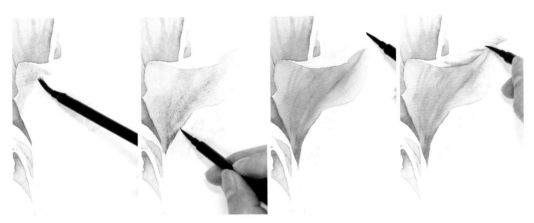

3 接着给右边这片叶子的叶背铺色，左右两边用黄绿色，中部用墨绿色，同时用笔顺着叶脉走向拉出线条，最底端接入**深墨绿色**。叶片正面的上边缘用淡蓝色，下接淡绿色，之后用墨绿色拉出线条，至边缘收尾，边缘颜色最重，用深墨绿色上色。

4 画右侧的小叶子。叶尖用淡蓝色，往下接淡绿色，靠近花朵的位置点染进墨绿色，往下柔化边缘。趁湿用墨绿色加重叶片的中部和右边缘。最后用墨绿色画出叶背颜色，边缘接淡蓝色。

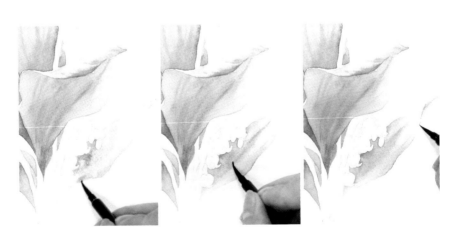

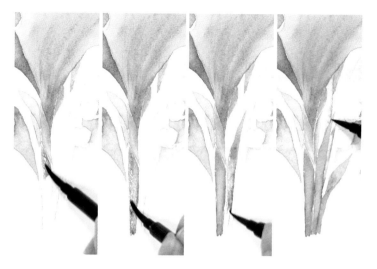
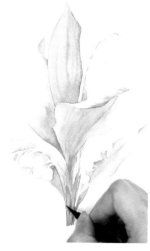

5 下面给鞘状叶和部分花葶上色。左侧植株上方的鞘状叶上部用暗绿色，下接淡绿色；下部的鞘状叶用**浅粉色**上底色，于两侧边缘点入**暗紫色**。中部植株的鞘状叶用**淡棕色**从上往下上色，下接浅粉色，两侧边缘点入暗紫色。右侧植株的鞘状叶用**棕色**上色，混入一些暗紫色。最后用黄绿色给下部分的花葶上底色，用墨绿色点入右边缘，表现花葶的暗部色彩。

6 用淡绿色给三支花葶剩余的部分上底色，用墨绿色加重暗部。这样，第一遍颜色就完成了。

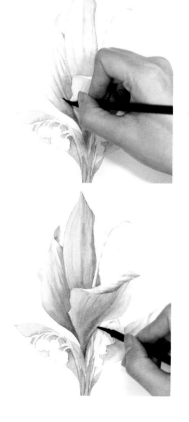
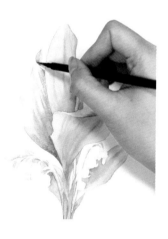

7 加深叶子暗部色彩：再次铺湿叶片，保留亮部不叠色，用墨绿色拉出叶脉，让其自然晕开。用深墨绿色加深暗部。

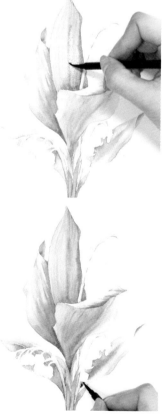

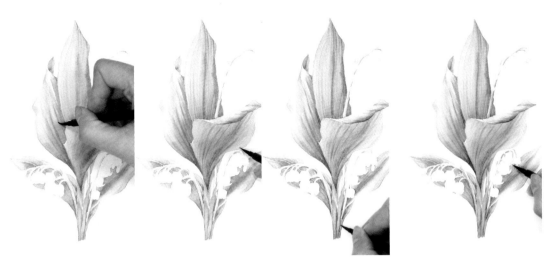

8 待颜色干透后，进一步细化叶脉线条：蘸取墨绿色，避开最亮的位置，在其他位置拉出叶脉线条，注意用笔轻柔，顺着叶子的曲度与生长方向拉线。最后用暗紫色加强一下鞘状叶的暗部色彩。

9 用**淡黄绿色**给花葶和未开放的花苞上色。

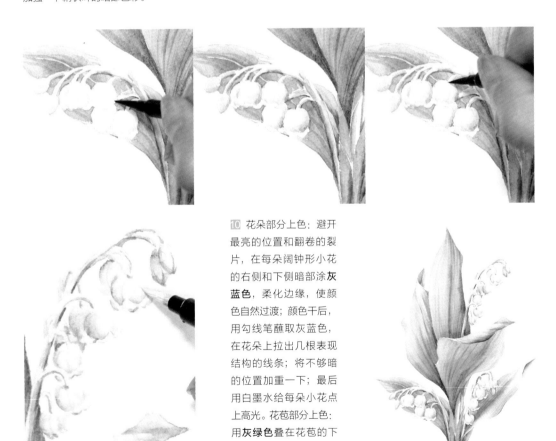

10 花朵部分上色：避开最亮的位置和翻卷的裂片，在每朵阔钟形小花的右侧和下侧暗部涂**灰蓝色**，柔化边缘，使颜色自然过渡；颜色干后，用勾线笔蘸取灰蓝色，在花朵上拉出几根表现结构的线条；将不够暗的位置加重一下；最后用白墨水给每朵小花点上高光。花苞部分上色：用**灰绿色**叠在花苞的下边缘，柔化边缘，并用灰绿色拉出线条。

11 作品完成。

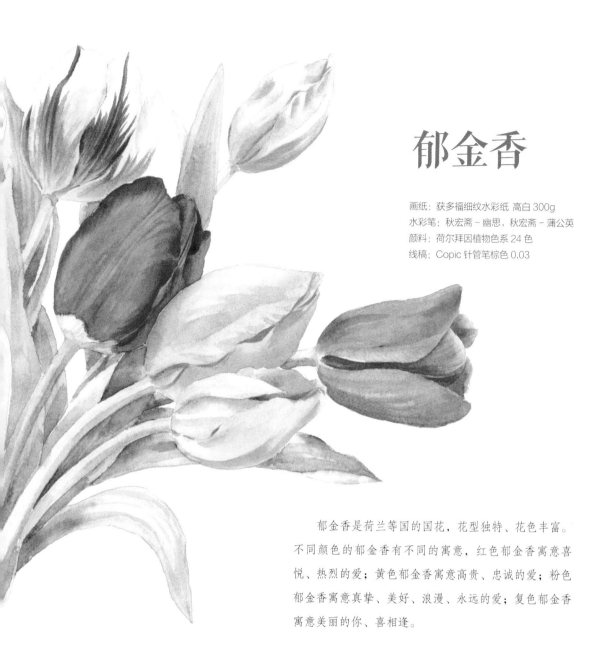

郁金香

画纸：获多福细纹水彩纸 高白 300g
水彩笔：秋宏斋 - 幽思，秋宏斋 - 蒲公英
颜料：荷尔拜因植物色系 24 色
线稿：Copic 针管笔棕色 0.03

　　郁金香是荷兰等国的国花，花型独特、花色丰富。不同颜色的郁金香有不同的寓意，红色郁金香寓意喜悦、热烈的爱；黄色郁金香寓意高贵、忠诚的爱；粉色郁金香寓意真挚、美好、浪漫、永远的爱；复色郁金香寓意美丽的你、喜相逢。

W093	W115	W134	W007	W019	W050	W034	W013	W066	W092	W062	W010
浅胭脂	永固紫	熟褐	吡咯红	朱红	喹啶酮黄	土黄	歌剧粉	永固绿	天蓝	蔷克绿	深红

1 绘制线稿

照片素材

线稿

郁金香的花单朵顶生，花被片外轮椭圆形，先端尖，内轮稍短，倒卵形；叶片条状披针形。上方这张郁金香照片经旋转后，呈现对角线构图，根据这个构图画出线稿。

2 花朵调色

浅群青 + 少量永固紫 + 熟赭 = 灰色

吡咯红 + 土黄 = 淡橙色

朱红 + 少量永固绿 = 暗棕色

永固绿 + 咪唑酮黄 = 黄绿色

吡咯红 + 少量霍克绿 = 暗红色

永固紫 + 少量浅群青 = 蓝紫色

蓝紫色 + 暗红色 = 暗紫红色

永固绿 + 天蓝 + 水 = 淡蓝绿色

朱红 + 少量永固绿 = 暗棕色

咪唑酮黄 + 少量永固紫 = 暗黄色

咪唑酮黄 + 少量永固绿 = 绿黄色

暗黄色 + 少量暗红色 = 深棕色

深红 + 歌剧粉 + 少量永固紫 = 深紫红色

永固紫 + 歌剧粉 + 少量浅群青 = 深紫色

3 花朵上色

1 先画复色的郁金香。蘸取**灰色**，在花被片的边缘上色，柔化边缘，表现出花被片的暗部；蘸取咪唑酮黄，从花被片基部上色，往上柔化边缘至透明。

 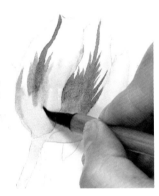 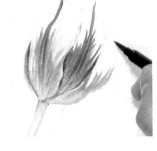

2 底色干透后开始叠色，描绘出花被片上的纹理：蘸取朱红色，从花被片顶端开始描绘花纹，到花被片中部时，往下接**淡橙色**，然后柔化边缘，使颜色自然过渡；侧边的花纹颜色相对较暗，往朱红色里添加一些永固绿，把红色的饱和度压下去，得到**暗棕色**，然后上色。用**黄绿色**给花茎上一层底色。

3 颜色干后，蘸取吡咯红加深花被片中部的条纹颜色以及花被片层叠处的暗部；用灰色在花被片边缘补充一些纹理；用少量暗棕色加强花朵右边缘暗部。蘸取霍克绿点在花被片基部以及花茎与花朵衔接处。

4 下面画红色的郁金香。用不同的红色给花朵上底色，让红色更有层次感：花朵边缘用朱红色，过渡到中间用吡咯红，中部混入少量歌剧粉，右下侧混入少量深红（注意避开花被片基部）；用干燥的笔把花朵中部的颜色吸走；蘸取调好的**暗红色**，把花被片层叠的暗部表现出来，暗部也有明暗对比，相对亮的暗部，用吡咯红上色。

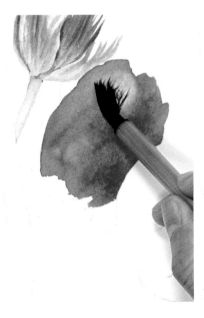 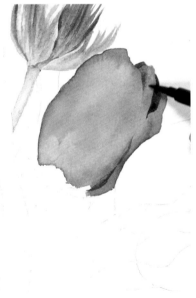

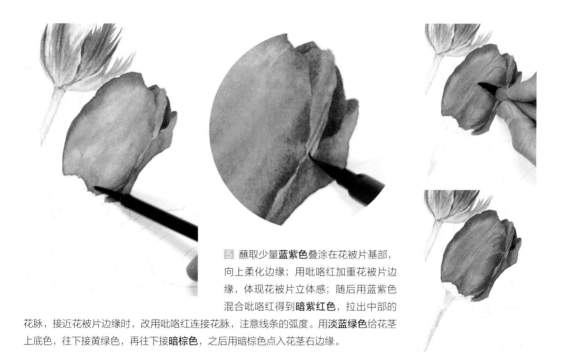

5 蘸取少量**蓝紫色**叠涂在花被片基部，向上柔化边缘；用吡咯红加重花被片边缘，体现花被片立体感；随后用蓝紫色混合吡咯红得到**暗紫红色**，拉出中部的花脉，接近花被片边缘时，改用吡咯红连接花脉，注意线条的弧度。用**淡蓝绿色**给花茎上底色，往下接黄绿色，再往下接**暗棕色**，之后用暗棕色点入花茎右边缘。

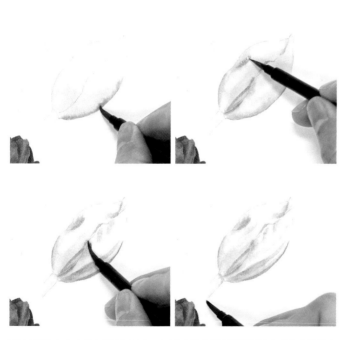

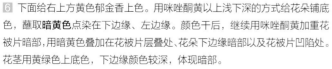

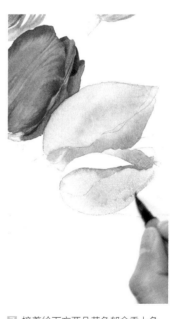

6 下面给右上方黄色郁金香上色。用咪唑酮黄以上浅下深的方式给花朵铺底色，蘸取暗黄色点染在下边缘、左边缘。颜色干后，继续用咪唑酮黄加重花被片暗部，用暗黄色叠加在花被片层叠处、花朵下边缘暗部以及花被片凹陷处。花茎用黄绿色上底色，下边缘颜色较深，体现暗部。

7 接着给下方两朵黄色郁金香上色。上面一朵用咪唑酮黄涂底色，趁湿在暗部点入暗黄色；下面一朵避开绿色的小花被片，下方涂**绿黄色**，上方从咪唑酮黄过渡至暗棕色，最后在基部点入少量永固绿。

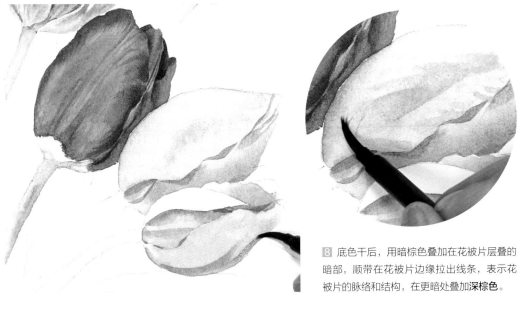

8 底色干后，用暗棕色叠加在花被片层叠的暗部，顺带在花被片边缘拉出线条，表示花被片的脉络和结构，在更暗处叠加**深棕色**。

9 用永固绿给小花被片基部上色，上方过渡至黄绿色，再过渡至透明；用黄绿色给花茎铺底色，暗部再次叠加黄绿色，加重色彩。

10 最后给粉色郁金香上色。用歌剧粉给上下两片花被片上底色，中间位置颜色淡，上下颜色深；里面的花被片也用歌剧粉上底色，调色的时候水更少，填涂在上下两片花被片中间的缝隙，往右边瓣尖过渡：瓣尖上部过渡至透明，下侧颜色更深。通过明度的不同，区分出后面小花被片的前后关系。

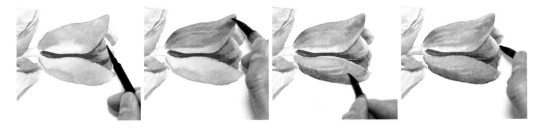

11 避开亮部，加重暗部。用**深紫红色**叠加在缝隙位置，顺势向右拉出线条。蘸取歌剧粉加深上面的花被片，并拉出线条；蘸取**深紫色**加深下方的花被片暗部，并拉出线条。最后用深紫红色加深后面小花被片的暗部。花朵部分上色完成。

4 茎叶调色

霍克绿 + 少量吡咯红 = **暗绿色**

永固绿 + 咪唑酮黄 = **黄绿色**

浅群青 + 少量霍克绿 + 少量吡咯红 + 水 = **浅暗蓝色**

浅群青 + 霍克绿 + 少量吡咯红 = **深蓝绿色**

5 茎叶上色

▣ 下面逐片给叶片上色。被遮挡的叶片用**暗绿色**，往下铺色时颜色逐渐加深；前方叶片的叶尖用**黄绿色**，往下接霍克绿；左侧大叶片的左边缘先用浅群青上色，往右接暗绿色，至右边缘接黄绿色；后方的叶片用调好的**浅暗蓝色**上色；花朵下方的叶片用**深蓝绿色**加重暗部颜色，用黄绿色过渡至亮部。

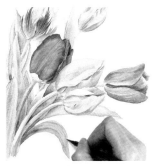
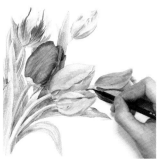

▣ 叶片的底色铺好之后，蘸取霍克绿拉出若干线条表现叶脉，最后用深蓝绿色加深暗部。

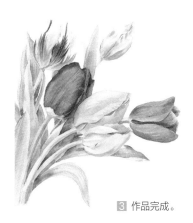

▣ 作品完成。

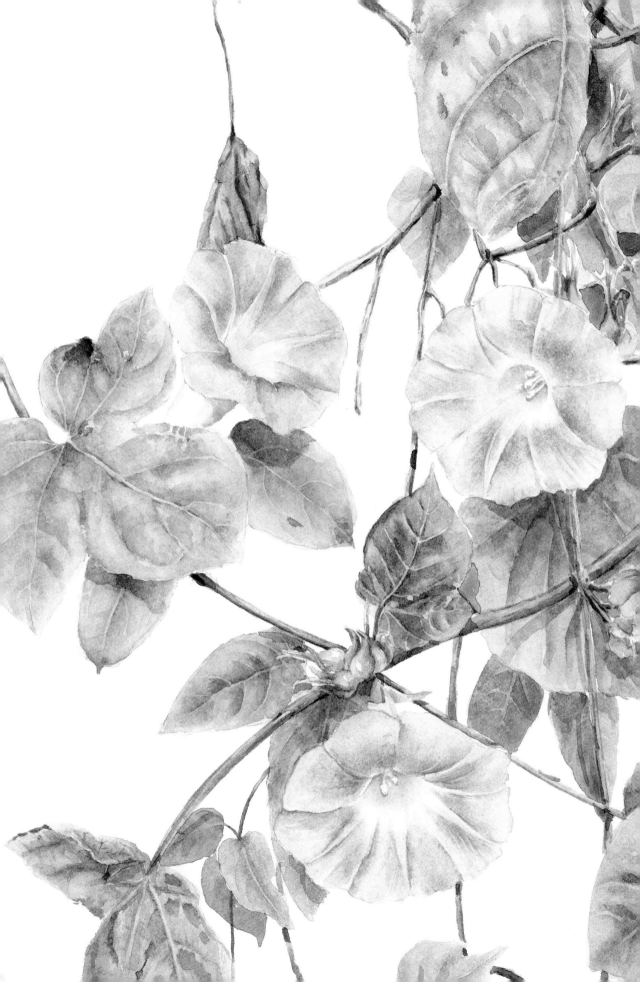

半屏构图花卉

- 大花紫薇
- 旱金莲
- 四季秋海棠
- 樱花

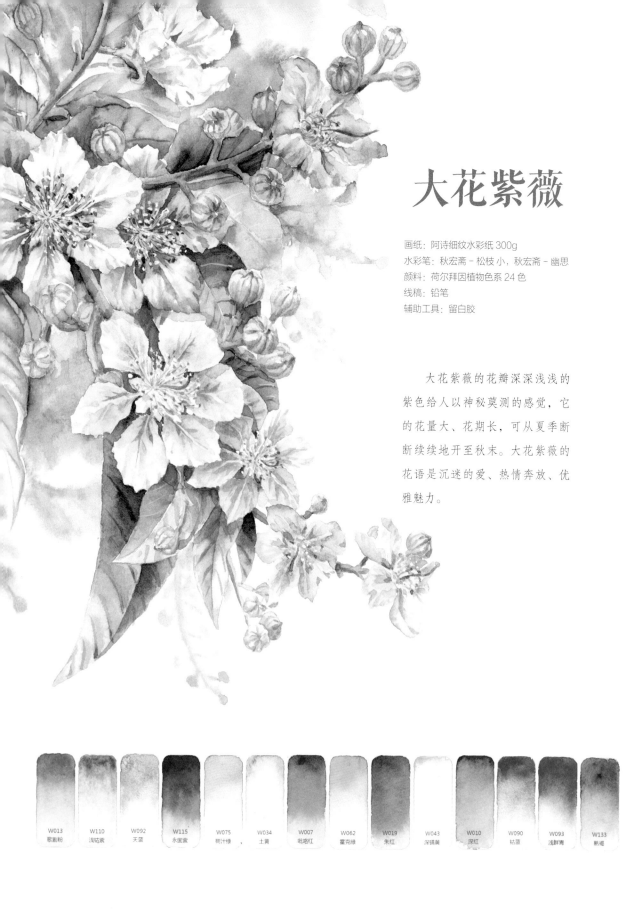

大花紫薇

画纸：阿诗细纹水彩纸 300g
水彩笔：秋宏斋 - 松枝 小，秋宏斋 - 幽思
颜料：荷尔拜因植物色系 24 色
线稿：铅笔
辅助工具：留白胶

 大花紫薇的花瓣深深浅浅的紫色给人以神秘莫测的感觉，它的花量大、花期长，可从夏季断断续续地开至秋末。大花紫薇的花语是沉迷的爱、热情奔放、优雅魅力。

W013 歌薇粉	W110 浅钴紫	W092 天蓝	W115 永固紫	W075 树汁绿	W034 土黄	W007 吡咯红	W062 霍克绿	W019 朱红	W043 深镉黄	W010 深红	W090 钴蓝	W093 浅群青	W133 熟褐

1 绘制线稿

照片素材

线稿

大花紫薇的花为顶生圆锥花序；花萼壶形，有12条棱，先端6裂，里面包裹着花瓣；每朵小花花瓣6片，长圆状倒卵形，有短爪；雄蕊很多，近等长；雌蕊比雄蕊长；叶革质，卵状椭圆形。左侧的实拍图构图不够美观，在脑海中将其转换成上紧下松的对角线半屏构图，根据大花紫薇的结构特点，画出线稿。

2 主花、花托、枝干调色

歌剧粉 + 少量永固紫 = **紫红色**

天蓝 + 水 = **淡蓝色**

歌剧粉 + 浅钴紫 + 不同比例的水 = 不同深浅的**粉紫色**

天蓝 + 浅钴紫 + 不同比例的水 = 不同深浅的**蓝紫色**

树汁绿 + 土黄 = **土绿色**

吡咯红 + 少量霍克绿 = **棕红色**

棕红色 + 歌剧粉 + 水 = **淡橘粉**

霍克绿 + 少量吡咯红 = **暗绿色**

3 主花、花托、枝干上色

1 大花紫薇的花瓣很薄，且多褶皱。先为中间三朵紧挨在一起的花朵上色，中间的花朵处于上方，颜色最淡，两侧的花朵处于下方，颜色深。用留白胶把花蕊点上小点进行留白，之后从右侧的花朵开始上色，上色时，先铺湿花瓣，再蘸取**紫红色**从瓣基上色，在瓣尖也点染上紫红色，留白花瓣的中部，最后拉出线条表现花瓣的褶皱。给这朵花的其余花瓣上色时混入些许**淡蓝色**，以增加颜色丰富度。

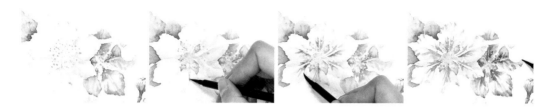

☑ 用淡蓝色、淡**粉紫色**和淡**蓝紫色**给中间花朵的花瓣上底色。底色干了以后，留白每片花瓣中部花脉，沿花脉往两侧以树枝状上色，接近瓣边时柔化边缘。这层颜色干透后，再次用紫红色和深**蓝紫色**加深花脉结构。同时留意瓣基之间的缝隙露出来的是花托的颜色，用**土绿色**填涂此处色块，边缘点入**棕红色**。左侧的花朵颜色较简单，用永固紫涂在边缘位置，以明确其与中间花朵的边界，其余区域用紫红色上色。

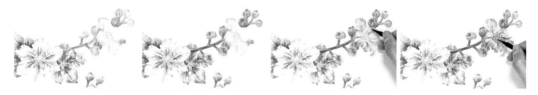

☑ 给三朵花所在枝条的右侧部分上色。枝干用**淡橘粉**上底色，点入棕红色让其有变化，底色干后用**暗绿色**、紫红色加重枝干下侧暗部。注意，越往末端的枝干越嫩，颜色越淡。右侧的小花的花蕊还没完全打开，呈黄绿色调，花朵呈紫色调，重点表现花瓣卷曲的状态以及花瓣的褶皱，用紫红色和深蓝紫色表现花瓣暗部；沿花瓣曲线画出褶皱；最后用棕红色画出还没展开的、弯曲的花丝，点涂花药，用深红拉出长长的花柱。花苞详细上色步骤见步下文。

☑ 回到三朵花，用猪皮擦把花蕊处的留白胶擦除干净，用勾线笔蘸取深镉黄点涂小花药，需要留一些白点不点满。蘸取熟褐，拉出花丝。再次蘸取熟褐，叠加点入些小点表现花药暗部。

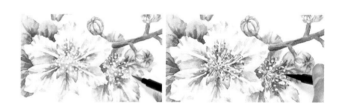

4 花苞、次要花朵调色

树汁绿 + 天蓝 + 水 = **淡青色**　　歌剧粉 + 朱红 + 水 = **淡橘红**　　吡咯红 + 歌剧粉 = **桃红色**　　吡咯红 + 歌剧粉 + 少量霍克绿 = **暗桃红色**

5 花苞、次要花朵上色

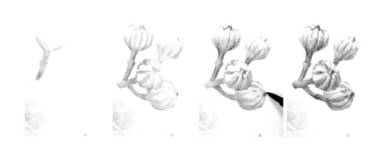

☑ 给花苞上色。花苞底色用**淡青色**，往下接**淡橘红**至花梗，使颜色自然过渡；趁湿蘸取淡橘红加深花梗暗部并拉出花萼的棱，蘸取暗绿色拉出花萼最暗处的棱线；用**桃红色**和**暗桃红色**（根据每个花苞的受光状态不同来选择）加深花苞的小尖以及棱线和花梗的暗部。

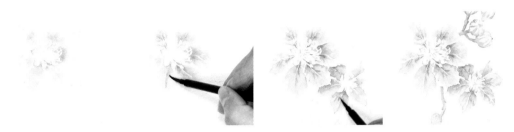

2 下方的这些花朵是作为画面的次要部分来表现的，颜色较上方花朵清淡一些，以淡淡的粉紫色调为主，配以淡蓝色作为提亮色，这里不使用留白胶来留白花蕊。

3 越往下的花朵越小，表现的范围有限，所以即使花瓣依然是很多褶皱的，但在上色的时候尽量减少细节，能表现花朵结构和明暗即可。下方花苞的部分也尽量使用与上方花苞不同的色彩偏向。枝条方面，上方枝条偏成熟，使用更多棕红色，下方枝条偏嫩，使用更多的黄绿色调。花朵部分上色完成。

6 叶子调色

钴蓝＋少量霍克绿＋少量深红＋不同比例的水＝不同深浅的**烟青色**

树汁绿＋深镉黄＝**黄绿色**

霍克绿＋少量树汁绿＋少量土黄＋少量吡咯红＝**中绿色**

霍克绿＋少量吡咯红＋少量永固紫＋不同比例的水＝不同深浅的**军绿色**

浅群青＋少量熟褐＋少量霍克绿＝**灰蓝色**

7 叶子上色

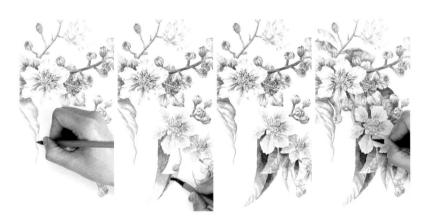

▲ 细节：上色时，用深烟青色明确花朵的边界。

1 下面开始给叶片上色，先给前面的几片大叶子上色。左侧叶子，先铺湿，然后蘸取浅**烟青色**描绘叶子正面边缘，往里拉出叶脉线条，靠近花朵下方的位置，颜色重一些；叶背则用**黄绿色**铺底色，边缘点入**中绿色**，同样拉出叶脉，叶尖点入棕红色。中部叶子，用深**军绿色**从叶片背面上方开始上色，往下接土绿色，颜色干后，用深烟青色上在叶片正面，柔化右边缘。接着用**灰蓝色**给右侧一些小叶子上色，花朵下方处用深烟青色，同时在叶尖增加一些绿色调，丰富色彩。

2 最后一步是创造虚化的背景。准备一杯干净的水，把笔洗干净，铺湿周围空白区域，用湿画法把虚化的叶子和花苞表现出来（见步骤 A – H ），这幅画就完成了。

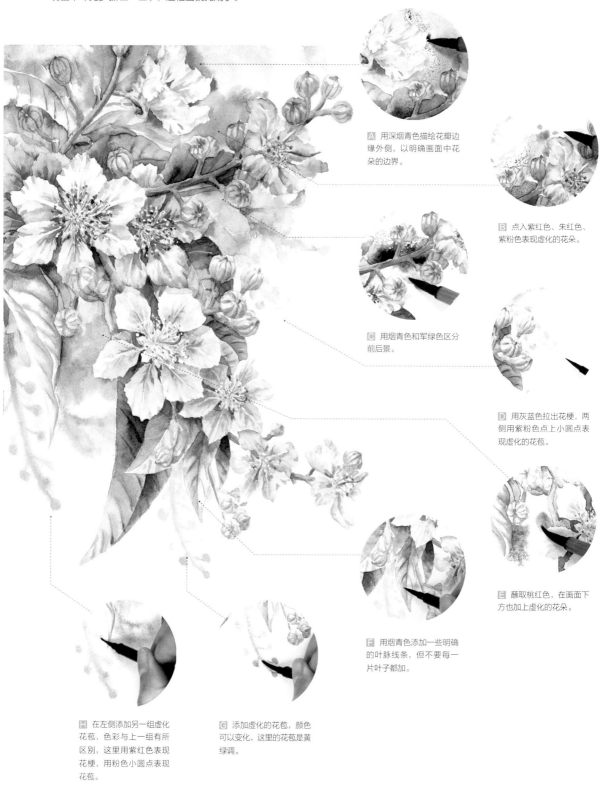

A 用深烟青色描绘花瓣边缘外侧，以明确画面中花朵的边界。

B 点入紫红色、朱红色、紫粉色表现虚化的花朵。

C 用烟青色和军绿色区分前后景。

D 用灰蓝色拉出花梗，两侧用紫粉色点上小圆点表现虚化的花苞。

E 蘸取桃红色，在画面下方也加上虚化的花朵。

F 用烟青色添加一些明确的叶脉线条，但不要每一片叶子都加。

H 在左侧添加另一组虚化花苞，色彩与上一组有所区别，这里用紫红色表现花梗，用粉色小圆点表现花苞。

G 添加虚化的花苞，颜色可以变化，这里的花苞是黄绿调。

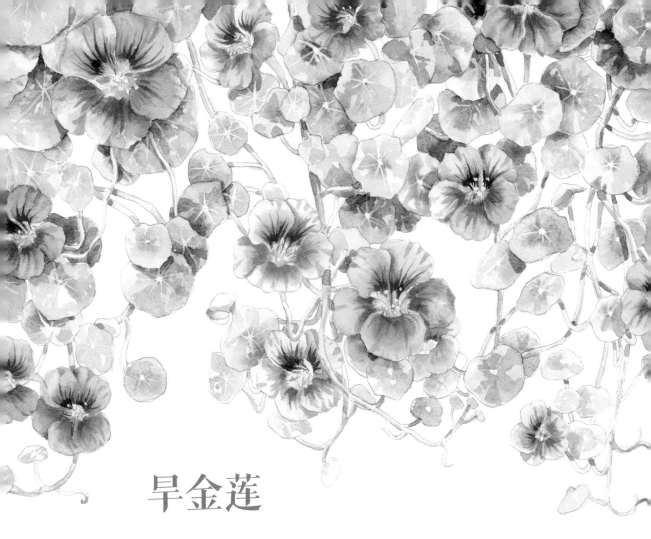

旱金莲

画纸：宝虹细纹水彩纸 - 学院级 300g
水彩笔：笔皇 ESCODA 1230#1、黑天鹅 3000S #6
颜料：美捷乐金装 24 色
线稿：Copic 针管笔棕色 0.03
辅助工具：白墨水、留白胶

　　旱金莲是一种蔓生植物，叶子圆圆的，像莲叶，橘红色的花朵像太阳一样明艳夺目，让人心情也跟着明亮起来。旱金莲寓意顺其自然、随遇而安、开心就好、炙热的爱情、爱国心等。

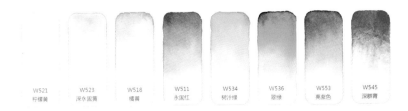

| W521 | W523 | W518 | W511 | W534 | W536 | W553 | W545 |
| 柠檬黄 | 深永固黄 | 橘黄 | 永固红 | 树汁绿 | 翠绿 | 亮紫色 | 深群青 |

1 绘制线稿

旱金莲的叶片圆形，边缘有波状的浅缺刻。单花腋生，
每朵花有 5 片花瓣，花瓣圆形。雄蕊 8 枚。长短互间。
为体现旱金莲蔓生的特性，本幅作品采用半屏构图，
根据旱金莲的结构画出线稿。

2 花朵调色

花瓣的颜色梯度变化：正黄 - 橘
黄 - 橘红 - 永固红 - 暗红

柠檬黄 + 少量深永固黄
= **正黄色**

橘黄 + 少量永固红 = **橘红色**

深永固黄 + 少量亮紫色
= **棕黄色**

橘黄 + 少量亮紫色 = **棕色**

永固红 + 少量翠绿 = **暗红色**

3 花朵上色

这幅画中有大量相似的花朵，在上色时，可根据自身喜
好选择不同色调和色相的颜色，呈现不同色彩倾向的色
彩（偏黄的或偏红的花朵等）；可通过用水的多寡让色
彩有明度的变化；也可以使用不同的上色方式，如湿画
法、干画法，让每朵花最终呈现的质感有所不同。

下面以局部示范的方法讲解如何上色。

花朵上色完成后

花朵的上色方式 1：全局上色（选取位于中下方的花朵示范）

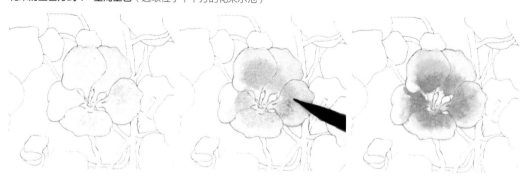

1 用调和好的**正黄色**铺满花朵，围绕花心一圈点入橘黄，之后再点入少量的**橘红色**，使颜色自然过渡，形成渐变。

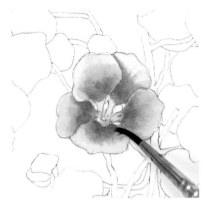 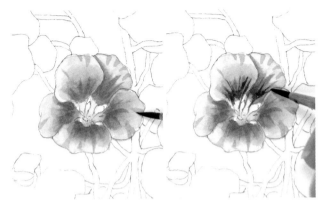

2 颜色干后，继续用橙红色为所有花瓣的基部附近添加色彩，注意瓣基和瓣尖都不要染上红色调；花瓣之间的暗部通过叠加朱红色表现。

3 蘸取永固红在朱红色的上层拉出线条。蘸取调和好的**棕黄色**和**棕色**给瓣尖画上几道短线（花瓣底色浅时，选择淡一点的棕黄色，花瓣底色深时，选择深一点的棕色），表示花瓣褶皱；最后蘸取调和好的**暗红色**，为上方两片花瓣添加花脉。

花朵的上色方式 2：逐片花瓣上色（选取位于左侧的花朵示范）

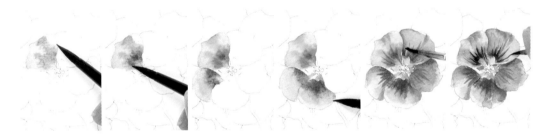

从左侧花瓣开始逐片上色，用正黄色铺底色，之后点入橘黄，继而在靠近花心位置先点入橘红色，后点入永固红。每一片花瓣都是如此。在上色时，注意通过叠加颜色把花瓣之间的暗部表现出来。最后用永固红从花心附近拉出线条，再用暗红色为上方两片花瓣添加花脉。

4 叶片调色

柠檬黄 + 树汁绿 + 不同比例的水 = 不同深浅的**黄绿色**

树汁绿 + 翠绿 = **正绿色**

深群青 + 水 = **淡蓝色**

正绿色 + 少量深群青 = **深绿色**

正绿色 + 少量永固红 = **暗绿色**

深群青 + 少量**正绿色** = **深蓝绿色**

5 叶片上色（选取位于左侧区域的叶片示范）

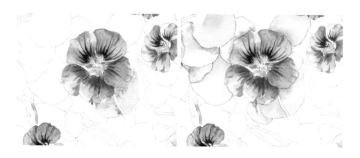

1 部分叶片上方有枝条，用留白胶覆盖这部分枝条，方便叶片上色。用**黄绿色**铺叶片的底色，在花朵下方点入**正绿色**，表现阴影；附近的叶片都使用不同深浅的黄绿色铺底色，叶片局部点入正绿色，某些后方的叶片点入**淡蓝色**，让叶片颜色有冷暖变化，一些暗部点入深群青。

2 部分叶片是花叶的，处理花叶的方法是在叶子的底色干透后，用比底色深一度的颜色，如正绿色、**暗绿色**，叠涂在上面，涂色时留出一些小空隙，同时在颜色湿润的时候在暗部点入**深绿色**。

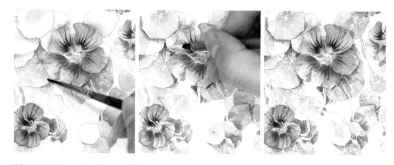

3 其余叶片上色时注意变化色彩，底色偏冷时，叠涂时相应也使用偏冷的颜色，如蓝绿色；一些叶片可画较大的花叶（即留更大的空隙），这样画面不会显得密集和细碎。这一层颜色干透以后，用勾线笔蘸取白墨水画出叶脉。

4 用**深蓝绿色**画出叶片上的投影。

5 蘸取白墨水，往里面添加柠檬黄，调成淡黄色，点涂在每朵花的花心附近，表现花蕊。

6 按上述方法把颜色全部上完，作品完成。

四季秋海棠

画纸：阿诗细纹水彩纸 300g
水彩笔：秋宏斋 - 蒲公英
颜料：美捷乐金装 24 色
线稿：Copic 针管笔棕色 0.03
辅助工具：白墨水

| W551 | W545 | W511 | W518 | W512 | W175 |
| 歌剧粉 | 深群青 | 永固红 | 橘黄 | 永固喹啶酮玫瑰红 | 亮棕色 |

| W536 | W535 | W521 | W561 | W570 |
| 翠绿 | 霍克绿 | 柠檬黄 | 赭黄 | 熟褐 |

四季秋海棠原产巴西，红艳艳的花朵在阳光下会呈现出闪闪的珠光。四季秋海棠外形与我国原产的秋海棠很相似，但寓意不同。秋海棠又叫"相思草""断肠花"，古人遇到爱情挫折时，常以秋海棠自喻，有相思、苦恋的寓意；而四季秋海棠寓意快乐智慧、相思、不舍。

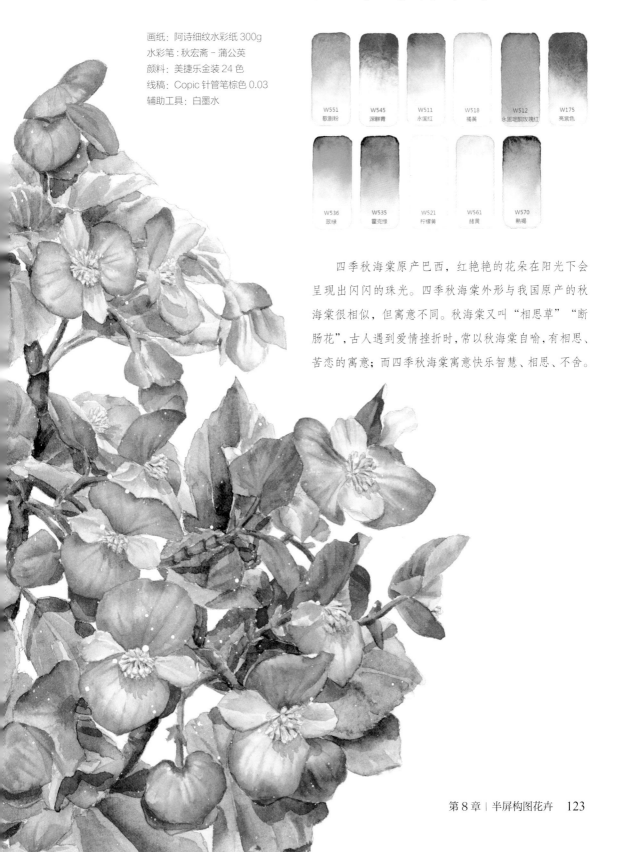

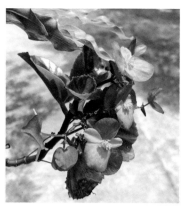

阳光下的四季秋海棠　　　　　线稿

1 绘制线稿

四季秋海棠的叶卵圆形，边缘具小锯齿；小花成聚伞花序，腋生，雌雄同株异花，每朵雄花有4片花被片，外面的2片较宽大，里面的2片较细长；雌花比雄花小。根据花的结构画出线稿。

2 花朵间的明暗关系

根据花朵的角度和朝向以及光源位置区分出明暗：自然光来自天空，右上角的花朵朝上开放，由于花瓣卷曲和花瓣的遮挡，可以看出花瓣中部受光，是亮部，下边缘则为暗部；而右下方的花朵朝下开放，那么下面的花瓣是受光的，上面的花瓣则相对暗。另外，左侧标识的几个暗部都是为了衬托前方花瓣而存在，以暗来突出亮，上色的时候把明暗关系理清，则形体也就清晰了。

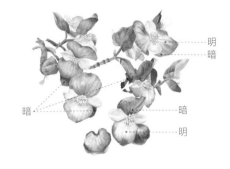

明
暗

暗　　　　　暗

明

3 花朵调色

花瓣固有色

歌剧粉 + 水 = **淡粉色**

橘黄 + 永固红 = **橙红色**

橘黄 + 歌剧粉 + 永固红 = **橘红色**

歌剧粉 + 深群青 + 水 = **淡紫色**

辅助色

深群青 + 水 = **淡蓝色**

橘黄 + 霍克绿 + 少量深群青 + 水 = **淡绿色**

暗部色

永固红 + 少量翠绿 = **暗红色**

4 花朵上色

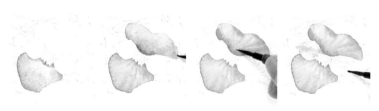

1 从中间的花开始上色。上下两片花瓣用**淡粉色**铺底色，花瓣边缘混入永固啶酮玫瑰红。下方花瓣基部点入**橙红色**，并顺着花瓣走向拉几条线条；上方花瓣基部点入**橘红色**，趁湿用永固啶酮玫瑰红拉出线条；两侧的小花瓣用淡粉色铺底色，左侧小花瓣的暗部混入**淡紫色**，右侧小花瓣基部混入**淡蓝色**。

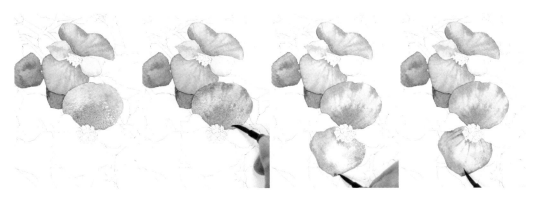

2 为下方的花朵上色。大花瓣用淡粉色铺底色，边缘点入永固啶酮玫瑰红，瓣基点入橙红色，花瓣的中部为亮面，不叠色，趁湿用**暗红色**拉线表现花脉。

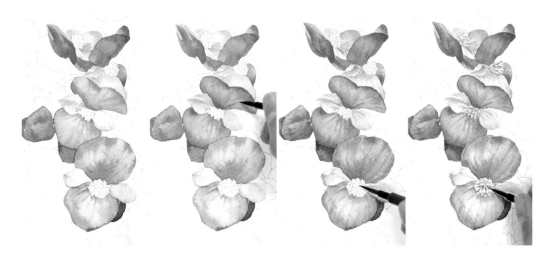

3 花朵两侧的小花瓣颜色淡，铺淡粉色并混入少量冷色调，例如淡蓝色、**淡绿色**，使之更加清、透、薄。第一层颜色干透后，用橘红色叠色加深花瓣固有色，用暗红色加重花瓣的暗部色彩。花蕊先蘸取柠檬黄上一层底色，颜色干透后，蘸取熟褐加重花蕊暗部，画出花蕊的立体感。

5 茎叶调色

霍克绿（7）+永固红（3）
=暖绿色

永固红（7）+霍克绿（3）
=暖红色

暖红色＋少量亮紫色=**暖紫色**

霍克绿（9）+永固红（1）
=暗绿色

暗绿色＋少量赭黄=淡黄绿色

暗绿色＋极少量深群青=
深绿色

暗绿色＋少量深群青=深
蓝绿色

深群青＋少量歌剧粉＋少量
熟褐＋水＝蓝灰色

6 茎叶上色

1 用霍克绿和永固红按不同的比例调配出不同的颜色给茎部上色：用**暖绿色**给茎部铺底色，边缘的暗部点入**暖紫色**；花梗的底色用**暖红色**；在花梗上方的茎部涂**暗绿色**，下方用熟褐，中部留白。

2 用上方调好的颜色按明暗关系给剩余的花朵及茎部上色。

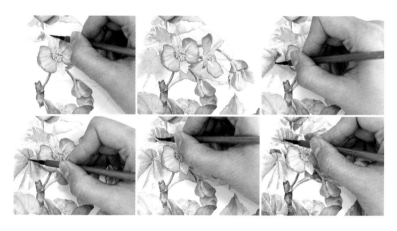

3 叶片是卵圆形的，叶脉呈发散状，嫩叶颜色偏黄，带一点红调，成年叶片偏绿，叶片在阳光下光泽度很高，显得结构分明。嫩叶用**淡黄绿色**铺底色，用暖绿色画出叶脉，上色时混入少量永固红，把颜色往红调拉。其他叶片用淡绿色表现最亮的面，用**深绿色**、暗绿色表现暗部及叶脉，最后用**深蓝绿色**给叶片之间添加投影。

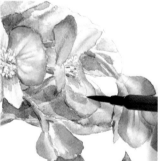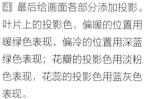

4 最后给画面各部分添加投影。叶片上的投影色，偏暖的位置用暖绿色表现，偏冷的位置用深蓝绿色表现；花瓣的投影色用淡粉色表现，花蕊的投影色用蓝灰色表现。

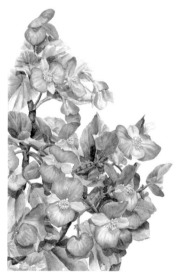

5 最后在画面上撒上一些白墨水作为点缀，绘制完成。

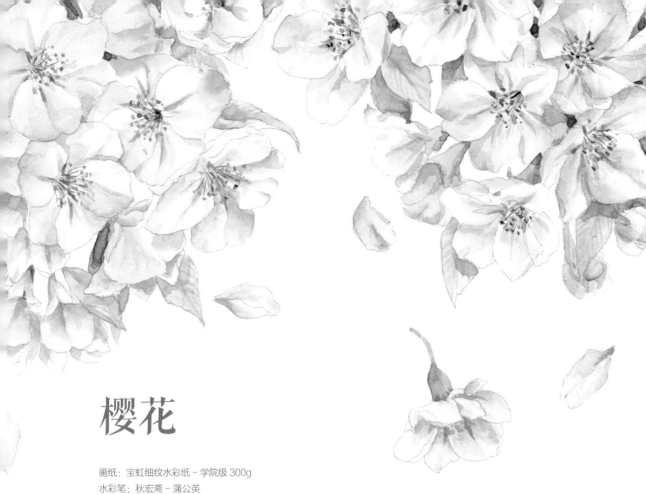

樱花

画纸：宝虹细纹水彩纸 – 学院级 300g
水彩笔：秋宏斋 – 蒲公英
颜料：荷尔拜因植物色系 24 色
线稿：Copic 针管笔棕色 0.03

　　樱花是春天的代名词，每年三四月份，白里透粉的樱花开满枝头，春风拂过，漫天飞舞的樱花让人沉醉，同时也夹带着淡淡的哀伤。樱花象征着爱情与希望，纯洁和美好。

| W013 | W019 | W090 | W093 | W066 | W062 | W034 | W043 | W120 | W133 |
| 歌剧粉 | 朱红 | 钴蓝 | 浅群青 | 永固绿 | 霍克绿 | 土黄 | 深镉黄 | 喹吖啶紫 | 熟褐 |

1 绘制线稿

樱花花瓣椭圆卵形，先端下凹，雄蕊比花瓣短。叶片倒卵形，先端尖，基部圆形。为呈现樱花飞舞的浪漫景象，这幅画作采用了上紧下松的半屏构图，下方点缀了落花，体现风吹花落的感觉，在绘制线稿时要注重风向感。

2 花朵调色

歌剧粉 + 水 = **淡粉色**　　钴蓝 + 歌剧粉 + 水 = **淡紫色**　　霍克绿 + 少量土黄 = **土绿色**　　歌剧粉 + 少量霍克绿 + 水 = **暗粉色**

　　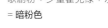

朱红 + 水 = **杏色**　　朱红 + 少量浅群青 + 少量霍克绿 = **暗杏色**　　啶酮紫 + 熟褐 = **紫褐色**　　钴蓝 + 水 = **淡蓝色**

3 花朵上色

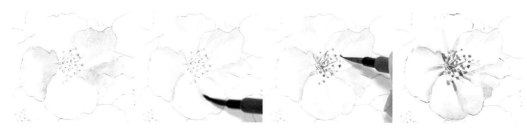

1 粉色花朵上色。先用**淡粉色**逐片花瓣上一层底色，花瓣是白和淡粉色过渡的感觉，然后用**淡紫色**画出花脉、加深花瓣间的暗部；用**土绿色**画出露出来的花托的颜色。花蕊用深镉黄和熟褐相间点涂。最后用歌剧粉局部加深一下花瓣的固有色，用**暗粉色**加深花瓣的暗部色彩，例如花瓣基部的褶皱。

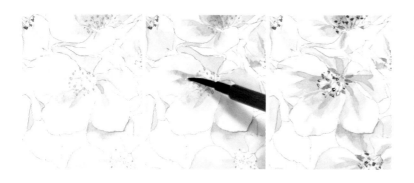

2 杏色花朵上色。杏色花朵和粉色花朵上色思路是一样的，颜色稍有变化：底色用**杏色**过渡到白色，加重花瓣颜色用深一点的杏色，暗部色彩用调好的**暗杏色**，花蕊依然用深镉黄和熟褐相间点涂，花蕊中心最暗的位置用**紫褐色**。

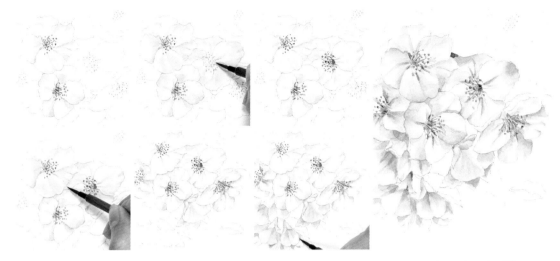

③ 成群花朵上色。花朵大概用粉色调和杏色调两种色调表现，上色的时候，两色穿插，丰富画面色彩。按照步骤 ① 、② 的方法一朵一朵上色，之后用**淡紫色**表现花朵之间的投影，用**淡蓝色**表现偏白的花朵的暗部，用**土绿色**来铺花托的底色，利用明度区分花托结构和明暗。

4 叶子调色

永固绿 + 深镉黄 = **黄绿色**

浅群青 + 霍克绿 + 少量朱红 = **深绿色**

5 叶子上色

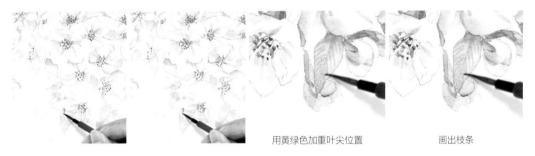

用黄绿色加重叶尖位置　　　　画出枝条

① 下面开始给叶片上色，画面在叶片的衬托下会更加清新和有生机。樱花的叶尖位置偏黄调一点，叶脉是规整的。叶片底色用**黄绿色**和土绿色铺满，干透后用**深绿色**加重暗部，用深一度的深绿色给叶片加上叶脉。最后画出樱花的枝条，使整个画面有骨架：用熟褐画出枝条的底色，再用紫褐色加深枝条的暗部色彩，一些嫩枝用**土绿色**平涂即可。

② 落花的上色思路与上方花朵是一样的，用淡粉色过渡到白色作为底色，用暗粉色、淡紫色区分出花瓣和花朵的结构。

③ 作品完成。

满屏构图花卉

- 夹竹桃
- '杰奎琳·杜普蕾'月季
- 睡莲
- 铁线莲

夹竹桃

画纸：阿诗细纹水彩纸300g
水彩笔：秋宏斋 - 幽思，秋宏斋 - 蒲公英
颜料：美捷乐金装24色
线稿：铅笔
辅助工具：白墨水

　　"夹竹桃，假竹桃也，其叶似竹，其花似桃，实又非竹非桃，故名"。夹竹桃盛开在绿肥红瘦的夏秋季节，簇簇拥拥地绽放的花朵，浪漫而唯美。夹竹桃的花语是虚幻美丽的爱情。它的植株有毒，因而也有注意危险、蛇蝎美人的寓意。

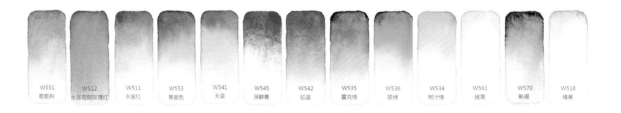

| W551 | W512 | W511 | W553 | W541 | W545 | W542 | W535 | W536 | W534 | W561 | W570 | W518 |
| 歌剧粉 | 永固喹吖酮玫瑰红 | 永固红 | 亮紫色 | 天蓝 | 深群青 | 钴蓝 | 霍克绿 | 苂绿 | 树汁绿 | 赭黄 | 熟褐 | 橘黄 |

1 绘制线稿

夹竹桃的叶多 3 片轮生，形状细长。花顶生，伞房状聚伞花序，小花的花冠漏斗状，花心处有流苏状撕裂的副花冠。结合花的形态特征，采用满屏构图画出线稿，表现花叶葱郁的景象。

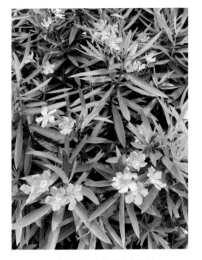

照片素材：马路旁的夹竹桃

线稿

2 枝叶调色

淡色

天蓝 + 水 = **浅蓝 A**

深群青 + 水 = **浅蓝 B**

树汁绿 + 水 = **浅绿 A**

霍克绿 + 水 = **浅绿 B**

深色

深群青 + 少量翠绿 + 少量熟褐 = **墨蓝色**

翠绿 + 少量深群青 + 少量歌剧粉 = **墨绿色**

亮紫色 + 少量钴蓝 = **蓝紫色**

墨蓝色 + 永定啶酮玫瑰红 + 少量熟褐 = **暖紫黑**

3 枝叶上色

■ 避开花朵的位置，手动留白，给背景铺上一层淡色：用调好的 **浅蓝 A**、**浅蓝 B**、**浅绿 A**、**浅绿 B** 这 4 种淡色给背景上色，嫩芽的位置用浅绿色系，其他地方用浅蓝色系。也可以使用留白胶把花朵覆盖再上色。另外调和**墨蓝色**、**墨绿色**、**蓝紫色** 3 种深色，随机点染在花朵边缘，颜色自然晕开，以表现暗部，突出花朵。

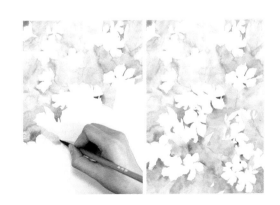

混色效果示例

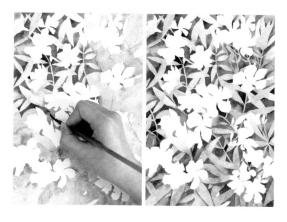

负形画法画叶子示例

2 用负形画法给叶子上色。底色干透后，蘸取上方调好的3种深色，避开枝叶轮廓上色。在上色的时候可以在深色里混一些**暖紫黑**，让画面颜色多一些冷暖对比。

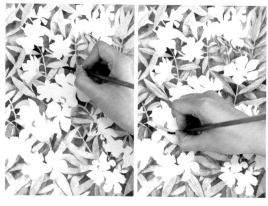

叶脉画法示例

3 夹竹桃的叶子是细长的，比较直，中间有一条浅色的叶脉，所以依然使用负形画法，往叶子两侧上色，留出中线，表现叶脉。上色时从上方调好的4种淡色中根据底色来选择颜色，底色是绿色就选绿色系，底色是蓝色就选蓝色系。上色时注意营造出色相、明度和饱和度上的变化，例如往绿色系里加入翠绿，局部上色，叶子色相就有了变化。颜色上的变化可以弥补叶子形态上的僵硬感。

4 最后用墨蓝色在最暗的色块里画出一些枝叶剪影，丰富画面。这样，枝叶部分就完成了。

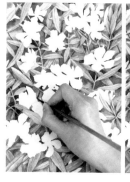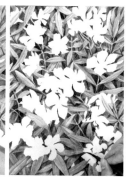

4 花朵调色

歌剧粉 + 水 = **浅粉色**

歌剧粉 + 少量永固红 + 水
= **浅暖粉色**

歌剧粉 + 少量天蓝 + 水 = **浅紫色**

歌剧粉 + 天蓝 + 水 = **浅蓝紫色**

歌剧粉 + 少量天蓝 = **紫色**

赭黄 + 水 = **浅黄色**

霍克绿 + 赭黄 = **黄绿色**

5 花朵上色

1 单朵花的上色方法。大部分花朵的固有色是**浅粉色**，快枯萎的花朵固有色为**浅暖粉色**，花瓣出现的焦边用橘黄表现；受光面（亮部）以很浅的浅粉色或白色表现，暗部用**浅紫色**、**浅蓝紫色**和**紫色**等冷色表现。逐片花瓣上色，花心留白，一部分花瓣用永定啶酮玫瑰红加深固有色。之后画副花冠，用紫色和永定啶酮玫瑰红画出流苏状副花冠的阴影，然后用勾线笔蘸取白墨水拉出副花冠。

2 花苞的上色方法。以三种颜色相接铺花苞底色，上方为永定啶酮玫瑰红，花朵基部接橘黄，花托和花梗位置接入调好的**黄绿色**。颜色干后，继续用永定啶酮玫瑰红加深暗部，用紫色拉出花苞扭转的纹理，用黄绿色加重花托和花梗的暗部。

3 成簇花朵上色方法。成簇花朵上色和单朵花上色的主要区别是处理好花朵之间的关系，重点描绘前方花朵，后方花朵作为衬托。浅粉色的底色铺完后，用浅紫色加重花瓣暗部，画出花瓣边缘的小褶皱；花心处避开花蕊的花丝和花柱，填上**浅黄色**，暗部用浅紫蓝色叠加，再用白墨水画流苏状的副花冠，最后用永定啶酮玫瑰红画出副花冠在花冠上的投影。

4 将墨蓝色加水调淡一些，画出花朵在枝叶上的投影、枝叶在花朵上的投影、花朵之间的投影、枝叶之间的投影等。因为这幅画主要采用负形画法，在最后可用勾线笔进行修边，把形体调整和谐。

5 作品完成。

'杰奎琳·杜普蕾'月季

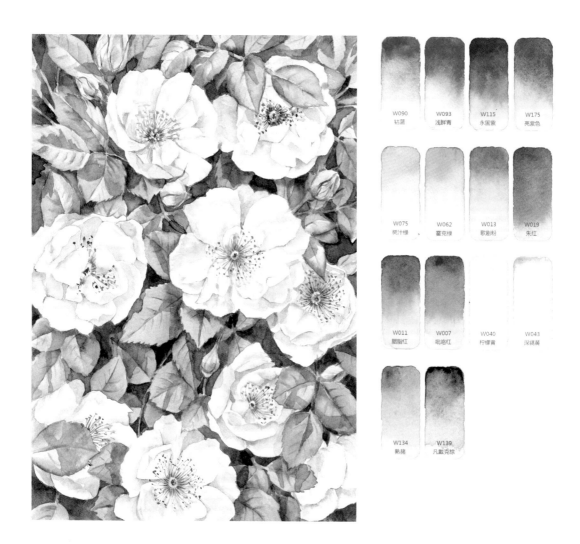

W090 钴蓝	W093 浅群青	W115 永固紫	W175 亮紫色
W075 树汁绿	W062 霍克绿	W013 歌剧粉	W019 朱红
W011 胭脂红	W007 吡咯红	W040 柠檬黄	W043 深镉黄
W134 熟褐	W139 凡戴克棕		

这是一款以天才大提琴演奏家杰奎琳·杜普蕾的名字命名的月季花。它的香气浓郁，花瓣洁白，雄蕊的花丝呈渐变的红色，花药金色，花蕊整体如绽放的烟花般绚烂。单朵花的花期很短，犹如杰奎琳·杜普蕾短暂而灿烂的一生。

画纸：阿诗细纹水彩纸300g
水彩笔：秋宏斋-夜蝉、秋宏斋-松枝小
颜料：荷尔拜因植物色系24色
线稿：铅笔
辅助工具：留白胶

1 绘制线稿

'杰奎琳·杜普蕾'月季的花瓣单瓣
到半重瓣，圆形花瓣呈平展状开放，
中心的花丝根根分明。采用全屏构图
画出线稿，呈现花繁叶茂的场景。

2 叶片调色

固有色 = 　　 =

霍克绿 + 树汁绿 + 水 = **淡绿色**　　淡绿色 + 柠檬黄 + 水 = **黄绿色**

树汁绿 + 少量朱红 = **暖绿色**

暗部色 =

浅群青 + 少量霍克绿 + 少量
吡咯红 = **墨蓝色**

少量浅群青 + 霍克绿 + 少
量吡咯红 = **墨绿色**

少量浅群青 + 少量霍克绿 + 吡咯
红 = **暗红色**

辅助色 = 　　

墨绿色 + 少量亮紫色 = **灰绿色**　　少量墨绿色 + 亮紫色 = **灰紫色**

嫩叶色 = 　　

朱红 + 少量树汁绿 = **棕色**　　吡咯红 + 凡戴克棕 = **红棕色**

3 叶片上色

1 在上色之前先用可
塑橡皮把线稿印淡。
避开花朵和花苞的位
置，用清水铺湿叶片
区域，用霍克绿以及
调好的**淡绿色**、**黄绿
色**、**暖绿色**铺底色，
表现叶片的固有色；
在靠近花朵的暗部点
入**墨蓝色**、**墨绿色**、
暗红色，使颜色自然
融合。

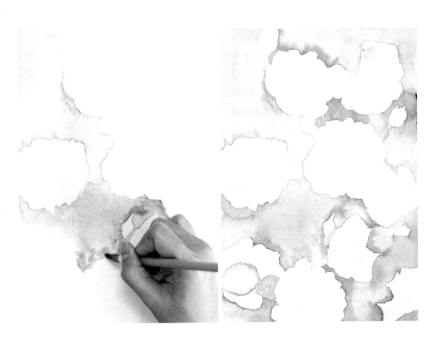

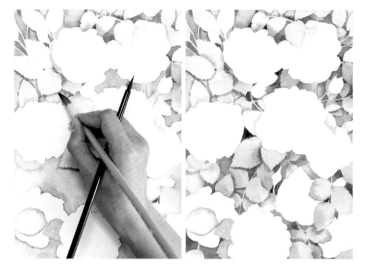

2 上一层颜色干透后，用墨蓝色、墨绿色和暗红色分别混入一点水调淡，以负形画法画出枝叶的形状，注意叶片边缘是锯齿状的，使用勾线笔可更好地勾勒细节。另外，为了画面带有一点安静和复古的感觉，使用亮紫色和墨绿色调出两个灰调的色彩（灰绿色和灰紫色），也用在这一步里进行混色。

小贴士

在调灰色调的时候尽量不使用黑色去调色，而是使用互补色去调色，这样调出来的灰色带有色偏，不沉闷。

3 嫩叶上色。嫩叶是黄绿色调的，用黄绿色和暖绿色为叶片上色；叶边呈红色调，点入调好的**棕色**以及**红棕色**来表现。如果颜料盘里有现成的棕色和红棕色，可以省去调色步骤。

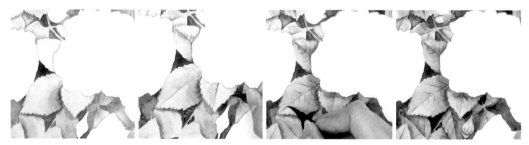

4 叶子上色。这几片叶子在花朵的后侧，靠近花朵的位置可视为暗部，先用墨蓝色给叶片的暗部上色，之后用墨绿色画出中脉和两侧的小叶脉。用黄绿色提亮叶片的亮部。最后，用暗红色、墨绿色、墨蓝色加强叶片四周的暗部，让叶片的形体更加突出。

小贴士

蓝是冷调，暗红是暖调，暗红可以较好地平衡叶片部分的色彩冷暖，但因为相对暖调的花朵的部分还没画，所以暗红色用量不用太多，点缀即可。

4 花朵调色

花瓣的固有色是粉色调的。对于白色的花瓣而言，暗部色彩为蓝紫色调；对于粉色的花瓣而言，暗部色彩则为粉紫色调。花瓣质地薄透，调色时多加水，调出淡淡的颜色，重色只留给最暗的位置。花朵被绿叶围绕，会受到环境色的影响，有些白色的花瓣会呈现周围的绿色调。花蕊根据花朵开放程度色的不同，使用不同的色彩。

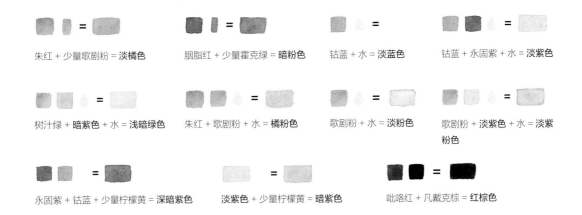

朱红 + 少量歌剧粉 = **淡橘色**　　胭脂红 + 少量霍克绿 = **暗粉色**　　钴蓝 + 水 = **淡蓝色**　　钴蓝 + 永固紫 + 水 = **淡紫色**

树汁绿 + **暗紫色** + 水 = **浅暗绿色**　　朱红 + 歌剧粉 + 水 = **橘粉色**　　歌剧粉 + 水 = **淡粉色**　　歌剧粉 + **淡紫色** + 水 = **淡紫粉色**

永固紫 + 钴蓝 + 少量柠檬黄 = **深暗紫色**　　淡紫色 + 少量柠檬黄 = **暗紫色**　　吡咯红 + 凡戴克棕 = **红棕色**

5 花朵上色

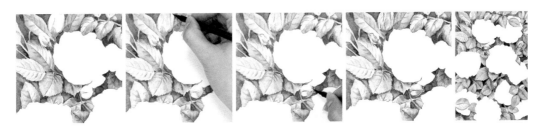

1 花苞上色。花苞比花朵颜色更鲜艳一些，在接近花托的位置会带有黄绿色调，苞尖的颜色最深，呈橘粉色调。用**淡橘色**涂在花苞尖部，往下接入柠檬黄。用**暗粉色**作为暗部色彩，添加在花苞的暗部。

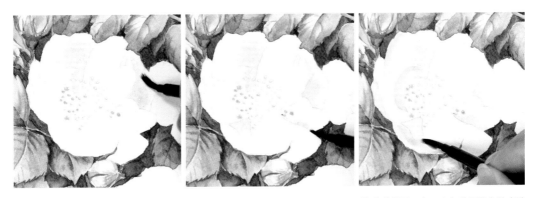

2 初开的花朵上色。初开的花朵，花瓣颜色略带粉色，花蕊呈黄橘色调。为了保持花药位置干净，上色前用留白胶点涂一下花药。留白胶干透后，蘸取**淡蓝色**和**淡紫色**为外层花瓣的暗部上色，柔化边缘，过渡到亮部。在受环境光影响的暗部用**浅暗绿色**上色。花瓣的边缘和背面颜色用**橘粉色**。

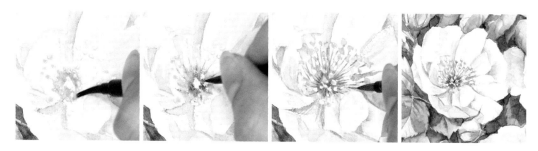

3 在等待花瓣颜色干的同时，可以换勾线笔开始给花蕊上色：中心留白，四周上一层柠檬黄，再点染一圈朱红；趁颜色未干继续点入吡咯红，并顺势往四周拉出花丝。颜色干透后用猪皮擦把留白胶擦除，在花药位置点涂深镉黄，并用熟赭连接花丝。初开的花朵上色完成。

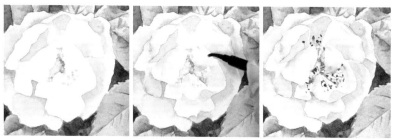

4 花瓣内卷的花朵上色。同样用留白胶点涂花药，留白胶干透后，蘸取淡蓝色和淡紫色给花瓣的暗部上色，自然过渡到白色。花瓣背面用橘粉色和**淡粉色**表现其固有色，暗部用**淡紫粉色**表现。花蕊处于被遮挡的位置，颜色饱和度降低，蘸取**深暗紫色**和**暗紫色**铺在花蕊位置，而花丝则用**红棕色**表现。

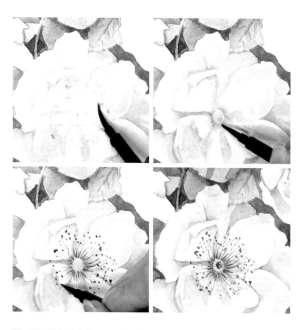

5 展开的花朵上色。展开的花朵的花瓣呈白色，只用极少量的淡粉色点缀个别花瓣。暗部呈现的是蓝紫色系的，整体颜色偏冷。花蕊用歌剧粉晕染，干透后继续用歌剧粉拉出花丝，花药用红棕色点涂。

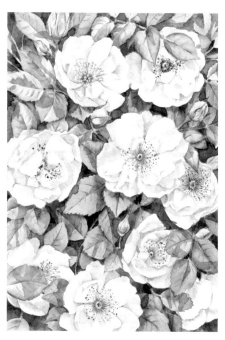

6 按上述方法，通过不同颜色的搭配，丰富花朵的色彩层次，表现不同时期的花朵状态，让画面更具生机。作品完成。

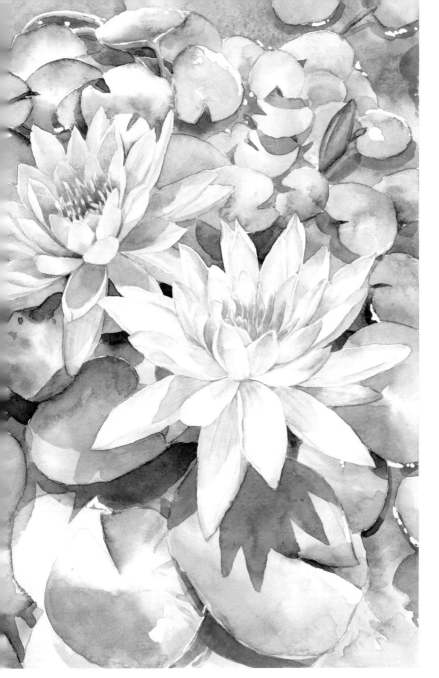

睡莲

画纸：宝虹细纹水彩纸 - 学院级 300g
水彩笔：秋宏斋 - 夜蝉、秋宏斋 - 松枝 小
颜料：荷尔拜因植物色系 24 色
线稿：铅笔
辅助工具：留白胶

　　睡莲生于水中，出淤泥而不染，被称为"水中女神"。在古埃及神话里，太阳是由睡莲绽放诞生的，因此睡莲也被称为"神圣之花"。白色睡莲圣洁美丽，花语是纯洁、纤尘不染、可望而不可即的爱；粉色睡莲如少女般灿烂，花语是朝气蓬勃、出淤泥而不染。

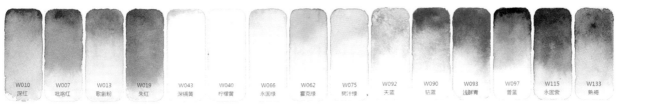

W010	W007	W013	W019	W043	W040	W066	W062	W075	W092	W090	W093	W097	W115	W133
深红	吡咯红	歌剧粉	朱红	深镉黄	柠檬黄	永固绿	霍克绿	树汁绿	天蓝	钴蓝	浅群青	普蓝	永固紫	熟褐

1 绘制线稿

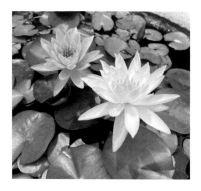

照片素材

睡莲的叶漂浮于水面，基部具深裂，全缘。花梗细长；萼片4片，花瓣和雄蕊数量较多，萼片和花瓣形状相似，宽披针形。结合花的形态特征，采用全屏构图画出线稿。

线稿

2 叶片、水面调色

霍克绿 + 少量吡咯红 = **暗绿色**

暗绿色 + 深镉黄 + 少量永固绿 = **黄绿色1**

暗绿色 + 较多深镉黄 + 少量永固绿 = **黄绿色2**

吡咯红 + 少量霍克绿 = **暗红色**

浅群青 + 霍克绿 + 少量吡咯红 = **暗蓝绿色**

普蓝 + 少量浅群青 + 永固紫 = **深蓝色**

永固紫 + 浅群青 = **紫蓝色**

天蓝 + 永固紫 + 水 = **淡蓝色**

歌剧粉 + 少量浅群青 = **淡紫色**

3 叶片、水面上色

1 先用留白胶覆盖在叶片边缘，预留出高光。

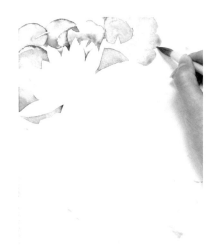

2 叶片是疏密有致的，对于连成一片的叶片可以一起上色，大片的叶片则逐片上色。蘸取调和好的**暗绿色**，给花瓣附近的叶片上色。在上色时，将颜色逐渐过渡至透明来表现叶片的光泽感，尤其是大叶片，用绿色过渡至大片的透明区域表现亮部，叶片的边缘点染**暗红色**。右上方的叶片群主要使用**黄绿色**，两种黄绿色的区别在于黄色调的轻重。

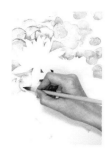

③ 向下继续为叶片上色，在花朵下方的叶片色彩较冷，所以混入蓝色调：使用调和好的**暗蓝绿色**为位于暗部的叶片上色，其余地方则用霍克绿上色，上色时注意颜色由深到浅过渡，表现叶片的亮部。

④ 在避开花瓣上色时，有很多尖角缝隙，注意使用聚锋能力强的笔头，或换一支勾线笔处理细小的缝隙。两花交界处的水面，使用调和好的**深蓝色**上色，突出花朵形状。左下角的几片叶片，使用非常淡的浅群青和黄绿色上色。

> ┌─ 小贴士 ─
> 上色时可能会形成水痕，不要来回叠加修改或擦色，
> 让它自然晾干，形成水彩画特有的质感。

⑤ 将水面位置铺湿，蘸取天蓝自画面顶部向下画出水色，下接钴蓝。叶片下方颜色稍深，在过渡至中部花朵下方时，使用普蓝、深蓝、**紫蓝色**这些较重的色彩；画面下半部分，颜色则转淡，转为**淡紫色**和**淡蓝色**。水色中的紫色调可平衡色彩：蓝色、绿色在色环的同一侧，加上紫色可平衡色彩。

> ┌─ 小贴士 ─
> 照片素材上看到的水色接近黑色，但在画的时候可主观处理：水面即镜子，镜子里是天空的颜色
> 和周围的环境色，主观剔除幽暗的环境色，只反映天空色彩，可让画面更加明朗。

⑥ 把叶片固有色太淡的地方加深，之后添加上投影：投影根据固有色来选择，叶片上的投影偏绿一些，用暗蓝绿色，绿色的比例多一点；靠近花瓣附近的投影，颜色更浓，用深蓝色；其他地方用色淡一些，调色时，水多一些。

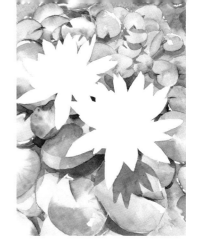

7 用猪皮擦把之前涂的留白胶擦干净，叶片和水面上色完成。

4 花朵调色

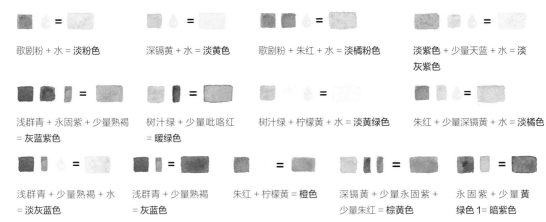

歌剧粉 + 水 = **淡粉色**　　深镉黄 + 水 = **淡黄色**　　歌剧粉 + 朱红 + 水 = **淡橘粉色**　　**淡紫色** + 少量天蓝 + 水 = **淡灰紫色**

浅群青 + 永固紫 + 少量熟褐 = **灰蓝紫色**　　树汁绿 + 少量吡咯红 = **暖绿色**　　树汁绿 + 柠檬黄 + 水 = **淡黄绿色**　　朱红 + 少量深镉黄 + 水 = **淡橘色**

浅群青 + 少量熟褐 + 水 = **淡灰蓝色**　　浅群青 + 少量熟褐 = **灰蓝色**　　朱红 + 柠檬黄 = **橙色**　　深镉黄 + 少量永固紫 + 少量朱红 = **棕黄色**　　永固紫 + 少量黄绿色1 = **暗紫色**

5 花朵上色

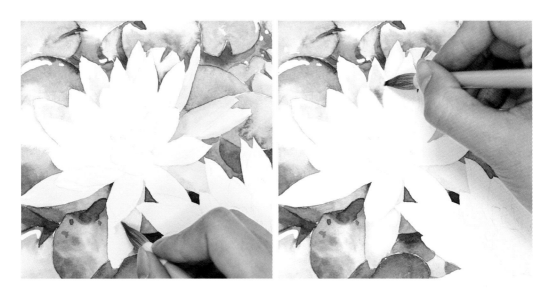

1 粉色花朵上色。先给外层萼片和花瓣铺底色。由于花瓣层层叠叠的遮挡关系，受光的瓣尖亮于里侧被遮挡的花瓣，用**淡粉色**画瓣尖亮部，逐渐过渡到淡紫色，表现花瓣的暗部。

2 靠近花蕊一圈的花瓣受花蕊环境色影响，会偏黄，瓣尖使用**淡黄色**，往里过渡到**淡橘粉色**，表现花朵在阳光照耀下呈现的暖色调。注意留白花蕊位置，最后刻画。蘸取深红填涂在花瓣里侧最暗的缝隙里。

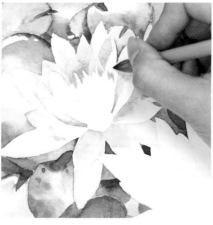

3 用淡紫色给花朵加上投影，花瓣是船形的，花瓣背面由于阳光照射，显得更加透明；用**淡灰紫色**则作为花瓣背面的暗部色彩，在更暗的地方则用**灰蓝紫色**加重。萼片的尖部带有一些绿色，用黄绿色刻画一下。

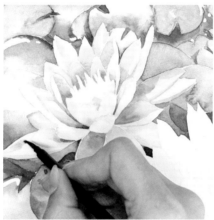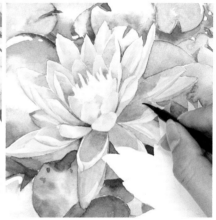

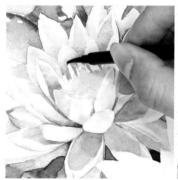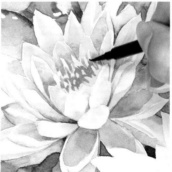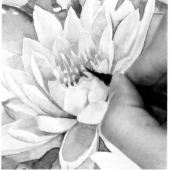

4 先用深镉黄把花蕊区域平涂铺满，颜色干透后，用负形画法画花蕊：蘸取朱红，画出每个小花蕊间的缝隙，小花蕊的形状出来之后，蘸取深红，点染在颜色最深处。

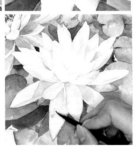

5 白色花朵上色。从外圈的萼片开始上色：铺湿萼片，基部点入淡灰蓝色，尖部点入**暖绿色**，向中部逐渐过渡至透明。靠近花蕊的花瓣用**淡黄绿色**上底色，避开花蕊。向光面的花瓣基部用调好的**淡橘色**上色。最后用**淡灰蓝色**画出投影，由于里圈的花瓣使用了淡黄绿色，叠加灰蓝色后颜色会呈灰绿色。花瓣基部之间的缝隙等较暗的位置，用**灰蓝色**表现。

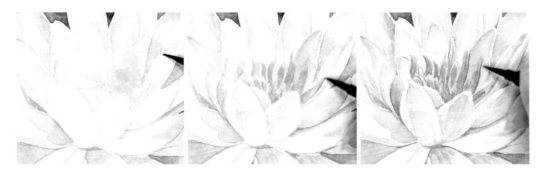

6 用深镉黄填满花蕊区域，旁边的小花瓣也填满深镉黄。用**橙色**画出小花蕊的形状，再用调好的**棕黄色**添加在小花蕊的右侧、拉出小花蕊的中线结构线，表现花蕊的暗部。棕黄色也作为旁边花瓣的暗部色以及花瓣边缘内卷产生的暗部色彩。

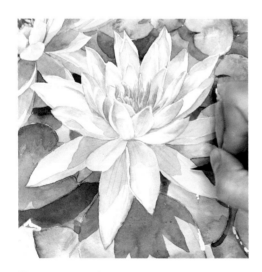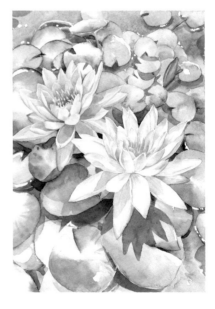

7 用勾线笔蘸取淡灰蓝色给外层萼片和花瓣拉出几条花脉。

8 用**暗紫色**和叶片用到的几个绿色细化花苞和叶柄等处的色彩，作品完成。

铁线莲

画纸：获多福细纹水彩纸 300g
水彩笔：秋宏斋 - 夜蝉、秋宏斋 - 松枝 小
颜料：美捷乐金装 24 色
线稿：铅笔

　　铁线莲是一种茎如铁线
般坚韧、花同莲花般高洁的
藤本花卉，容易攀爬成花墙。
花色繁多，常见紫色、红色、
白色等，花朵不同开放阶段
会呈现不同颜色。铁线莲的
花语是高洁、美丽的心。

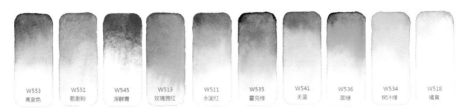

W553	W551	W545	W513	W511	W535	W541	W536	W534	W518
亮紫色	歌剧粉	深群青	玫瑰茜红	永固红	霍克绿	天蓝	翠绿	树汁绿	槠黄

1 绘制线稿

铁线莲的叶为二回或一回三出复叶，小叶窄卵形或披针形。花单生于叶腋，平展开放，无花瓣，萼片花瓣状，倒卵圆形，中脉明显。花丝宽线形，花柱短，柱头膨大成头状。

2 叶子调色

霍克绿 + 天蓝 = **青蓝色**

霍克绿 + 少量永固红 + 水 = **暖绿色**

霍克绿 + 少量永固红 = **深绿色**

霍克绿 + 稍多的永固红 + 水 = **橄榄绿**

树汁绿 + 少量永固红 = **黄绿色**

玫瑰茜红 + 少量霍克绿 = **暗红色**

暗红色 + 少量翠绿 = **暗紫红色**

3 叶子上色

底色混色示例

> **小贴士**
>
> 花朵是比较大的，手动留白比较方便，藤蔓的位置比较纤细，可以先用留白胶覆盖，再铺底色。

■1 用调好的**青蓝色**、**暖绿色**以及霍克绿、树汁绿铺底色，铺色时避开花朵和藤蔓。

■2 底色干后，根据线稿，用负形画法画叶子，即留出叶子的部分不上色，其余部分用调好的几种深一些的绿色（**深绿色**、**橄榄绿**）上色。在一些暗部，例如花朵边缘、藤蔓边缘等位置，点入**深绿色**、深群青，让暗部颜色偏冷。加重暗部颜色的

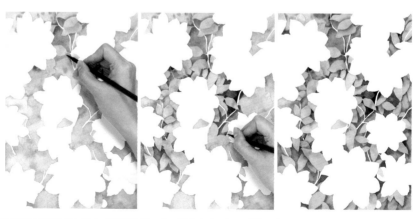

这一步，可以在用负形画法画叶片时以点入的方式同时进行，也可以待颜色干透后进行叠色。

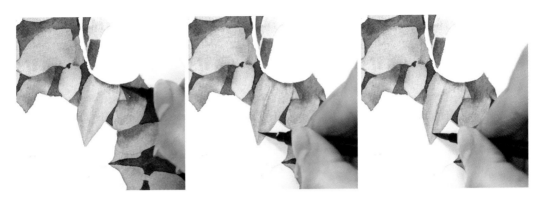

3　画出叶脉。铁线莲叶子的叶脉不是很明显，在整幅画中只需要对部分叶子进行叶脉的添加，背景的叶子不需要添加细节。添加叶脉时注意用比底色深一些的颜色叠加在叶子两侧往叶边揉开，留白中部线条，表现叶脉。

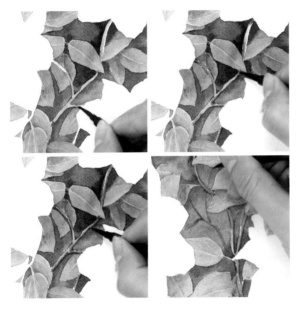

4　藤蔓上色。先用调好的**黄绿色**铺底色，随机点入**暗红色**，自然晕开；半干状态下用**暗紫红色**添加藤蔓暗部色彩。最后，在背景上描绘藤蔓的投影线条，丰富细节。

5　枝叶绘制完成。

4 花朵调色

歌剧粉 + 亮紫色 + 水 = **淡紫色**

霍克绿 + 水 = **淡绿色**

歌剧粉 + 水 = **淡粉色**

玫瑰茜红 + 亮紫色 = **紫红色**

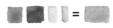

亮紫色 + 深群青 + 少量橘黄 + 少量歌剧粉 = **暗蓝紫色**

5 单朵花上色

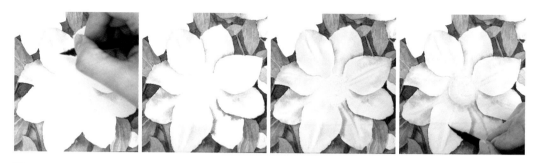

1 花朵以浅紫色为主，不同开放程度的花朵颜色有所不同，初开小花颜色偏绿，上色时注意添加淡绿色，开放后期的大花颜色偏淡、偏白。使用湿画法将花瓣状的萼片铺湿后上色，用调好的**淡紫色**从萼片边缘点入颜色，到萼片中部拉出两条线。注意为部分萼片点入**淡粉色**，增加色彩丰富度，萼片之间的暗部色用**暗蓝紫色**表现。花蕊的一圈外沿也需要用蓝紫色表现，柔化边缘。整体的颜色干透后，蘸取**淡绿色**，往萼片中部薄薄地叠加一层，使颜色自然过渡，柔化边缘。

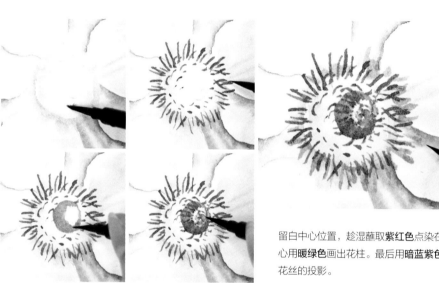

2 花蕊部分上色。用**淡粉色**涂在花蕊四周，干透后，蘸取**紫红色**，围绕圆心呈散射状画出细线表现花丝。蘸取玫瑰茜红给雌蕊处涂上底色，留白中心位置，趁湿蘸取**紫红色**点染在下边缘位置。中心用**暖绿色**画出花柱。最后用**暗蓝紫色**在花蕊下方画出花丝的投影。

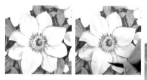

3 花蕊完成后，继续完善萼片的部分。蘸取**淡紫色**在每片萼片两侧画出短粗线，表现其褶皱；蘸取**暗蓝紫色**，加水调淡一些，在萼片中间拉出两三条线，加深萼片的中脉。

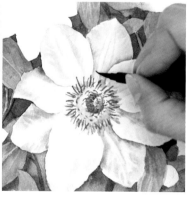
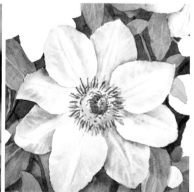

6 多朵花一起上色

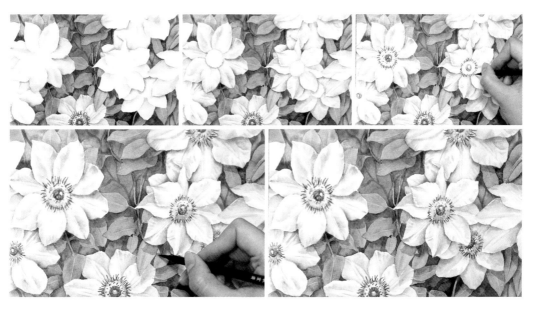

在画成群的花朵时，整体上色比较方便。先用**淡紫色**和**淡粉色**为每片萼片上底色，用**暗蓝紫色**作为萼片之间以及花朵之间的暗部色，区分好边界。第一层颜色上完后，得到基本的形体结构，然后继续花蕊和细节的上色，完成花朵的上色。最后蘸取**深绿色**，加水调淡一些，在花朵下方的叶子上画出投影。

小贴士

如何保持花朵的清透感，避免脏色

绿色和紫色混合在一起容易形成脏色，在萼片上色时，如果采用湿画法，则以紫色为主色，淡绿色为辅色，避免过多来回混色，从而避免两色相融。如果使用干叠色法，可分前后顺序来上色：如先上紫色，干透后再在中部花脉处叠涂淡绿色；反过来，如先上淡绿色，则干透后再往花瓣边缘叠涂紫色（见下图）。

按上述上色方法给整幅画作上色，作品完成。

微型画廊

雏菊、千里光花束

泼墨石斛兰

苣荬菜

虎刺梅

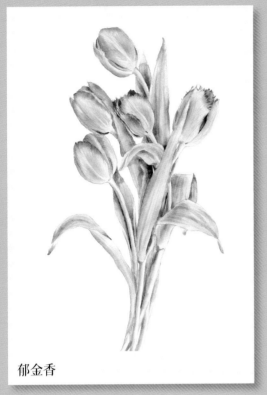

郁金香

桔梗

鸡蛋花

牵牛花

风铃草

水团花

粉色矮牵牛

垂丝茉莉

红色扶桑花